beginning *photography*

beginning

photography

GEORGE T. CARVER
EUGENE E. LEE

Mt. Hood Community College

PRENTICE-HALL, INC., ENGLEWOOD CLIFFS, NEW JERSEY 07632

Library of Congress Cataloging in Publication Data

Carver, George T., 1933–
 Beginning photography.

 Bibliography: p.
 Includes index.
 1. Photography. I. Lee, Eugene E. (date)
II. Title.
TR146.C325 1985 770′.28 84-18135
ISBN 0-13-071440-2 (pbk.)

Editorial/production supervision and interior design: *Hilda Tauber*
Cover design: *Ben Santora*
Manufacturing buyer: *Harry P. Baisley*
Page layout: *Peggy Finnerty*

Printed in the United States of America

10 9 8 7 6 5 4 3 2 1

ISBN 0-13-071440-2 01

PRENTICE-HALL INTERNATIONAL, INC., *London*
PRENTICE-HALL OF AUSTRALIA PTY. LIMITED, *Sydney*
EDITORA PRENTICE-HALL DO BRASIL, LTDA., *Rio de Janeiro*
PRENTICE-HALL CANADA INC., *Toronto*
PRENTICE-HALL OF INDIA PRIVATE LIMITED, *New Delhi*
PRENTICE-HALL OF JAPAN, INC., *Tokyo*
PRENTICE-HALL OF SOUTHWEST ASIA PTE. LTD., *Singapore*
WHITEHALL BOOKS LIMITED, *Wellington, New Zealand*

contents

preface

With so many photography textbooks available in a variety of styles and levels, it is important to distinguish how this book differs from others.

First, this book is intended for a first course in black and white photography. It supplements what an instructor does in the classroom and the lab.

Second, there are marked differences in the way various instructors handle instructional problems related to exposure, processing, printing, and visualization. This book aims at the middle ground, leaving the instructor room for individual approaches.

Third, attention is paid to techniques not usually covered in beginning photography texts. These include tips on processing and printing as well as post-printing details such as print intensification, bleaching, spotting, and mounting.

The book is organized around a concept of explain, practice, explain, etc. An annotated bibliography suggests references for further study. We devote a chapter to artificial and existing light. In other texts artificial light is often covered in too complex a manner to let students experiment and learn through observation and practice.

A chapter is devoted to composition because this area needs to be discussed even though there are many approaches to the subject. We avoid rules, but discuss factors and choices that students should consider as they approach subject matter.

It is our hope that a simplified basic text will ease the instructor's task, leaving the more complex material and treatment for advanced classes.

acknowledgments

We wish to acknowledge the many contributions of photography students and others at Mt. Hood Community College. In particular, to Dave Gorsek, Sandy Dalich, Lorna Hughes, Sharon Croghan, LuLu Khaw and Jill Clark, we owe our thanks for their willingness to be subjects for many of our photographic illustrations. Thanks to Michael Krumm for his depth of field photographs. Many thanks to Mark A. Kooy for his pen and ink illustrations. We are also grateful to several faculty members, staff, and friends for their encouragement, and to Vavene and Patsy for putting up with us.

GEORGE T. CARVER
EUGENE E. LEE

1

the camera

All cameras, regardless of size or shape, have several elements in common. These include a simple light-tight box, complex camera body or a bellows enclosure, a lens and a lens diaphragm, a shutter or time control, a viewing and focusing system, and a means of transporting or changing the film.

Figure 1-1 Basic Camera Components
All cameras contain these basic features: a light tight box, viewfinding system, lens, shutter, fixed or adjustable aperture, and a film transport.

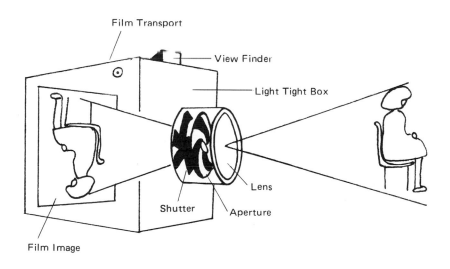

Film Transport

View Finder

Light Tight Box

Lens

Shutter

Aperture

Film Image

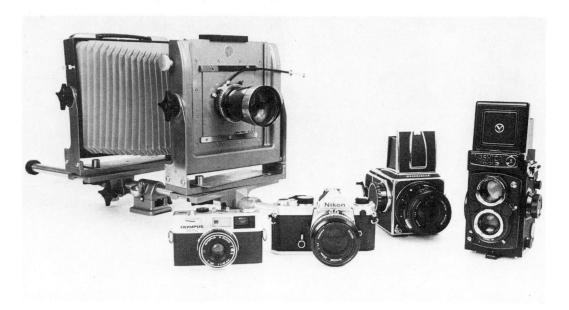

Four Camera Types
Cameras can be classified according to their viewing systems. From left are a ground glass view camera, optical rangefinder, twin lens reflex, and a single lens reflex.

Sometimes many or all of these elements are overlooked when a beginner makes a decision to buy a camera having adjustable controls. The prime factor is often the cost of the camera. While price is important, you should ask yourself what you want photography to do for you. Are you more concerned with landscapes, people, or sporting events? Or do you want to make close-ups that show great detail? Perhaps you want a camera that will serve a variety of uses. Taking successful pictures depends on knowing the advantages and disadvantages of various types of cameras, their film formats, and their viewing and focusing systems.

Viewing and Focusing Systems

The *viewfinder* is the camera's sighting and framing mechanism. There are fives types of viewing systems. These are:

1. Optical Viewfinder
2. Optical Rangefinder
3. Single Lens Reflex
4. Twin Lens Reflex
5. Ground Glass or View Camera

optical viewfinders and rangefinders

There are really two kinds of optical viewfinders. One is a simple optical viewing frame called a viewfinder. The other incorporates a focusing mechanism to sharpen the image on cameras with adjustable focus lenses. This system is called an optical rangefinder or rangefinder.

Viewfinder Cameras using the simple viewfinder are generally classified as small format snapshot cameras. They are the instant loading cartridge type. They are inexpensive, easy to use, and require no knowledge of photography to operate. The image seen in the viewfinder is considerably smaller than life size. Because of this, details in the scene often go unnoticed. The more expensive versions of these simple cameras include built-in automatic light-measuring systems and electronic flash for low light use.

Rangefinder The rangefinder is really two optical viewers, one inside the other. The smaller viewer is the rangefinder. It is located in the center of the larger viewer. When the focusing ring of the lens is rotated, two images of the same subject, seen in the smaller viewer, are brought together to form a single image; the subject is then in focus. The image is now framed within the larger viewer and the picture taken.

Figure 1-2 Optical and Rangefinder Viewing Systems
The simple optical viewfinder, left, is located over the lens. It gives a rough idea of what the final image will look like. The more expensive rangefinder optical system, at right, provides better viewing control through frame lines. It also provides sharp focus by aligning a double or split view into a single image.

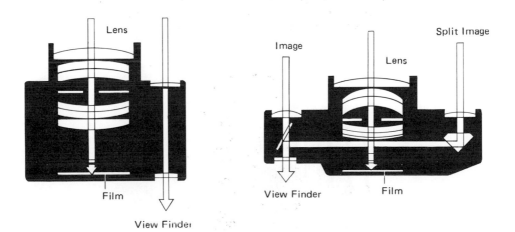

Because an optical viewfinder or rangefinder and the picture-taking lens are not on the same visual axis, the top of the picture can sometimes be cut off accidentally. This condition, called *parallax*, is the difference in what the viewfinder shows and what the lens actually sees. Cameras without built-in parallax correction often need to be tilted upward slightly to give the subject more "headroom" when taking close-up pictures.

Rangefinder cameras are light, compact, and easy to use. They often have automatic or adjustable exposure control through a built-in exposure meter. This gives the photographer more creative opportunities than is possible with the simple snapshot camera. A big advantage of this camera type is a quiet, front-mounted shutter, useful in candid situations.

Because of the limitations in the viewing system and the fact that most rangefinder cameras do not have interchangeable lenses, the rangefinder camera is often not the best choice. If close-up images are wanted or distant subjects must be magnified, other camera systems should be considered. The rangefinder camera, however, is an ideal candid camera in most outdoor situations.

single lens reflex

In the single lens reflex (SLR) system, light reflected from the subject passes through the lens and onto a mirror. From the mirror, light is reflected up into a mirrored prism, where it is seen right side up and corrected right to left in the eyepiece.

Figure 1-3 Single Lens Reflex Viewing System
In a typical SLR viewing system, light passing through the lens strikes a movable mirror. When the mirror is in viewing position, light is directed to a prism where the image is seen right-side-up and corrected from left to right. When an exposure is made, the mirror moves up for a fraction of a second, allowing light to strike the film.

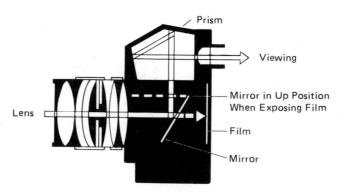

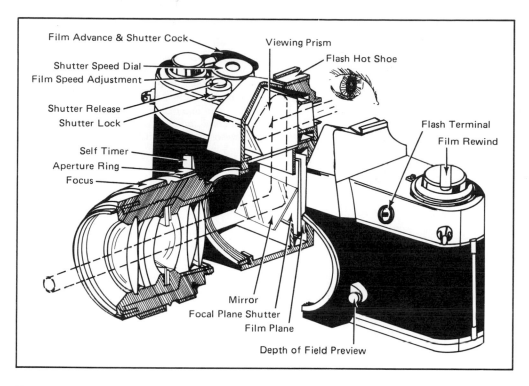

Figure 1-4 A 35mm Single Lens Reflex Camera

The image is made sharp with the focusing ring on the lens barrel. When the shutter release button is depressed to make an exposure, the mirror in the viewing system moves up, the shutter opens, and light strikes the film. After the exposure, the shutter closes and the mirror returns to its original viewing position.

For most amateurs and many professionals, the 35mm SLR camera is ideal. The camera is both small and lightweight. It usually has a built-in metering system, interchangeable lenses, and accessories, such as a motor drive for action photography. The ability to view the scene through the lens is a great benefit in composition and determination of focus. Some care should be taken with framing the subject. Most SLR viewing systems see a bit more of the subject than is seen on the film.

Disadvantages lie mostly in the small film size that limits the amount of quality possible in print sizes larger than 8 × 10 in. In addition, camera shake caused by mirror and shutter movement can contribute to a loss of sharpness. To overcome camera shake, SLR cameras are normally operated with shutter speeds faster than those used with optical viewfinder or twin lens reflex cameras.

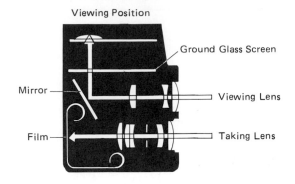

Viewing Position

Ground Glass Screen

Mirror

Viewing Lens

Film

Taking Lens

Figure 1-5 Twin Lens Reflex Camera
Viewing System
*The twin lens reflex (TLR) camera uses medium
format film and a simple system of one viewing
lens and one picture-taking lens. The image is
not corrected from left to right, making camera
positioning awkward for beginners.*

twin lens reflex

As the name reveals, twin lens reflex (TLR) cameras have two lenses. The top lens is the viewing and focusing lens. The bottom lens is the picture-taking lens. Like the SLR system, the TLR also uses a mirror in its focusing system. However, the TLR mirror is built in a fixed position and directs light coming through the viewing lens upward to a ground glass viewing screen. Since there is no prism,

Figure 1-6 Parallax
*Parallax, or mismatched viewing, occurs when the optical viewing camera or the twin
lens reflex are too close to the subject. The lens and the viewing system do not see
the same images within the viewing frame at distances of 6 feet or less. The most
obvious result is head cutoff.*

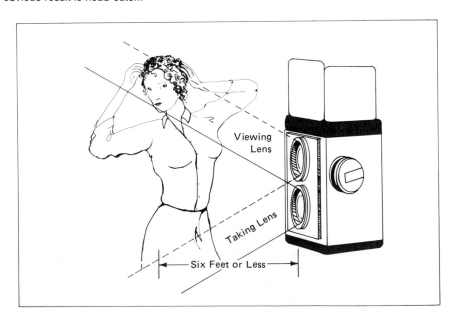

Viewing Lens

Taking Lens

Six Feet or Less

the image is not seen corrected left to right. Many beginners using this camera find it hard to follow action as a result.

TLR cameras also suffer from parallax problems when the subject is six feet or closer to the camera.

Advantages of the TLR camera include a larger medium format film size that allows for quality enlargements. The TLR can be used in several positions, something most small format 35mm SLRs cannot do since the eye must be held to the viewing prism. TLRs can be held at waist level or placed on the ground. They can be held at eye level or held upside down and placed overhead, useful in crowds. They can also be turned sideways or used pointing backward.

TLR disadvantages are several. The TLR is bigger and heavier than most 35mm cameras. Most TLR cameras do not have interchangeable lenses. Because of certain optical limitations in the TLR viewing system, images seen are not as bright or as easy to focus as they are with 35mm SLR cameras.

ground glass or view camera

Ground glass viewing is the system used in the view camera and in certain field cameras or older 4 × 5 in. press cameras. In this system, light reflected from the subject passes through the camera lens and is projected onto a piece of ground glass located at the film plane. The image being composed by the photographer is seen as being both upside down and reversed from left to right. The photographer sees exactly what the lens sees, without benefit of corrections from mirrors or prisms. As a result, this camera system is most used by professionals and advanced amateurs who have trained themselves to compose images that are seen upside down.

Focusing a ground glass camera is accomplished by changing the distance between the lens and film plane through adjustable

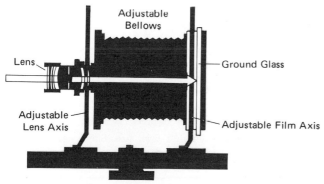

Figure 1-7 Ground Glass Camera Viewing System
The view camera uses direct ground glass viewing, producing an image that is upside down and uncorrected left to right. This camera is intended for professional use in landscape, architectural, and advertising photography. Both the lens plane and film plane can be tilted, swung, or shifted to correct for various perspective distortions.

light-tight bellows. A black focusing cloth or focusing hood is normally needed to shield the viewing screen from glare.

View cameras are one of the choices of professional photographers. The advantages of the view camera over other camera types have to do with perspective, depth of field, and film size.

1. PERSPECTIVE Both the film plane and the lens plane can be tilted, swung, or shifted. These movements reduce perspective problems that hinder architectural or product photography with most other camera systems. For example, a photograph of tall buildings taken with a viewfinder, SLR, or TLR camera usually shows the building lines converging. With a view camera, the various movements can adjust the building lines so that they appear parallel.

2. DEPTH OF FIELD View cameras can also produce images with great sharpness from a distance in front of the image focus point to a distance behind this point. This is known as depth of field and is discussed later in the chapter.

3. FILM SIZE Finally, view cameras have an advantage of a large film size. (See Table 1-1, which compares different film sizes.) Most view cameras use a film size 4 × 5 in. or larger. When compared to

TABLE 1-1 Film Sizes and Film Formats

SMALL FORMAT

1. Cartridge or Instamatic Type. These are preloaded and drop into the film chamber. They are used mainly in less expensive automatic cameras. The film size measures 1 × 1 in.
2. 110 Film. The film size is comparable to 16mm film or slightly larger than ½ in.
3. 35mm Film. This popular film size measures 1 × 1½ in. and comes in cassettes of 20, 24, or 36 exposures. It can be purchased in rolls for use in a bulk film loader. Many amateurs and professionals use this film size because of its convenience in sports, news, and fashion work.

MEDIUM FORMAT

120 Roll Film. The film is supplied in a paper-backed roll containing 8, 12, or 16 exposures. The film measures 2¼ in. wide, but its length varies with the camera used. Once a popular amateur film, this film format now finds favor with professionals and serious amateurs. Film sizes larger than 35mm produce larger, fine-grained prints.

LARGE FORMAT

Sheet Film. Sheet film is most often used in the 4 × 5 in. size. Some view or studio cameras are equipped to handle sheet film as large as 8 × 10 in. Sheet film is used by advanced amateurs and professionals in studio and landscape applications.

35mm film size of 1 × 1½ in., a view camera produces an image that is usually sharper and more detailed because image size is larger and less magnification is needed when making a large print.

Disadvantages of the view camera lie in size and weight as well as the difficulty of capturing moving subject matter. The camera must be used on a heavy tripod. Various adjustments must be considered in relation to perspective. It is not unusual for the view camera photographer to spend 30 minutes or more in setting up and composing a single picture!

The Lens

Modern camera lenses are a combination of several elements of finely ground convex and concave glass. The various lens surfaces are coated to reduce reflection and improve light transmission. Today's lenses are marvels of computer-assisted design. They are both more sharp and more crisp in low light/low contrast situations than lenses made only a few years ago.

focal length

Lenses are categorized for certain optical qualities by their optical length. This is known as focal length. The focal length of a lens is the distance from the film plane to the approximate center of the lens, sometimes called the *nodal point,* when the lens is focused at infinity. Infinity with most normal camera lenses is a distance somewhat greater than 50 feet from the camera position.

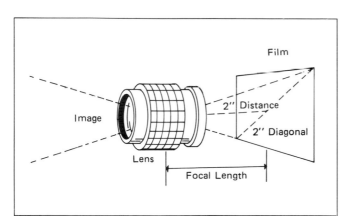

Figure 1-8 Focal Length
Focal length is found by measuring the distance from the optical center of the lens to the film plane when the lens is focused at infinity. The focal length is equal to the diagonal of the film used for a normal lens. Thus, a 50mm or 2-inch lens is the normal lens for a 35mm camera because the film diagonal measures 2 inches.

When a camera is purchased, the lens usually supplied with the camera is called the normal lens. A normal lens has a focal length that is approximately equal to the diagonal of the film size. This means that when a normal lens is focused at infinity, the image that is projected through the lens and onto the film plane results in a circular image whose diameter is equal to the maximum diameter of the outside lens element. Lenses with focal lengths longer than normal (telephoto), or shorter than normal (wide angle), project images whose diameters are not equal to the diameter of the film.

A 35mm camera has a film size of 1 × 1½ in. The diagonal of this film size is two inches. Therefore, the normal lens for a 35mm camera has a focal length of about two inches or 50mm. Lens focal length is usually described in millimeters.

If a larger film or camera size is used, the focal length of the normal lens will be larger. For example, a medium format SLR or TLR camera uses roll film with a diagonal measurement of three inches. The normal lens for this film size has a focal length of three inches or 75mm. The normal lens for a 4 × 5 in. film size is about 165mm.

Because there are so many variations in cameras, not all normal lenses will be exactly the lengths stated above. Some 35mm cameras, for example, have normal focal length lenses as short as 44mm or as long as 58mm.

wide-angle lenses

Wide-angle or short focal length lenses include more of the scene than would a normal lens at the same distance. As the angle of view increases for the wide-angle lens, objects appear smaller. That is, they will have a smaller image size. This is neither good nor bad. The advantage of being able to include more of the scene is sometimes offset by the loss of image quality when making big prints.

Typical wide-angle lenses for a 35mm camera include 9mm (fisheye), 17mm, 24mm, 28mm, and 35mm. The shorter the focal length, the more curvature of the image will be apparent. Sometimes the curvature distortion is effective in adding to pictorial qualities. Sometimes the distortion can produce gross effects, as in extreme close-ups in portraits.

The photographer is also aware that wide-angle lenses exaggerate the differences between near and far objects. Subject matter close to a wide-angle lens tends to be considerably larger than that of a normal lens, while backgrounds appear to be more distant than they really are.

Wide Angle Lens Distortion
Objects closest to a lens are seen as being larger than objects of the same size but further away from the lens. In this picture, made with a 28mm wide-angle lens, the sidewalk and lamppost are quite out of proportion compared to the buildings nearby.

telephoto lenses

Any lens whose focal length is longer than the film diagonal is called a telephoto or long lens. Telephoto lenses have a much narrower angle of view and greater magnification than does a normal lens.

Like their wide-angle counterparts, telephoto lenses can create distance or space distortion compared to a normal lens. By compressing space and narrowing the angle of view, the telephoto lens gives subjects the look of being closer or more compressed than they actually would be.

Telephoto lenses are usually grouped into medium telephoto and long telephoto. Medium telephoto lenses for 35mm cameras range from about 70mm to 150mm. Lenses longer than 150mm are generally considered long telephoto. Because magnification of the image also magnifies camera movement, telephoto lenses should be used with a tripod whenever possible.

Medium telephoto lenses are ideal for portraits or for shooting candids with less chance of being observed. Long telephoto lenses are best for magnifying images where it would be difficult for the photographer to move closer, as at sporting events.

Telephoto Lens Compression
This photo of the same apartments shown on page 11 was made with a 200mm telephoto lens. Note both the magnification and compression of the image.

teleconverters

It is also possible to achieve telephoto effects from normal lenses. A tele-extender or teleconverter may be used. The normal lens is first removed from the camera and replaced with the teleconverter. The lens is then placed in front of the converter. Teleconverters are normally available in $2\times$ or $3\times$ magnification. It doubles or triples the relative focal length of the lens. A $2\times$ teleconverter, used with a 50mm lens, increases the normal focal length to 100mm or medium telephoto.

Teleconverters are relatively inexpensive and increase the versatility of lenses on hand. But the addition of a teleconverter reduces the relative sharpness of the lens used with it and may cause distortion. A normal lens is really not designed to "see" in a compressed, telephoto manner.

Teleconverters also reduce the amount of light that can reach the film. The additional glass elements add distance from the lens to the film plane, causing light intensity to weaken inversely as it travels to the film plane. Using a teleconverter, therefore, calls for a substantial increase in exposure.

zoom lenses

Zoom lenses allow the photographer the convenience of having several focal lengths available in the same lens. The short-range zooms, especially models equipped with close-up macro focusing, are ideal for closer than normal focusing distance images. Short-range zooms have focal lengths of about 28mm to 85mm. A popular size with many photographers is the mid-range zoom of about 70mm to 210mm. Zoom lenses are also available in the 200mm to 500mm range.

Zoom lenses increase the versatility of a basic system. Yet they are often heavier and bulkier than fixed focal length lenses. The resolution or sharpness of quality zoom lenses often rival or surpass that of fixed focal length lenses.

mirror lens

A mirror lens uses internal mirrors to extend the focal length while shortening overall length. The focal length of a mirror lens usually starts at 500mm. A sturdy tripod, therefore, is a must, because the slightest movement of the camera will render the image worthless.

One disadvantage is that the mirror lens is limited to a single, fixed lens opening. This leaves the shutter as the only exposure control. Mirror lenses also have a readily identifiable, *signature* problem. In bright, specular highlights, the point of light will be recorded as donut-shaped, that is, a circle of light with a dark center.

The Aperture

The lens opening or *aperture*, together with the shutter, determines how much light will pass through the lens and strike the film. The aperture has often been compared in function to the iris diaphragm in the human eye. The eye adjusts to different lighting conditions by regulating the size of the pupil within the iris. In bright light, the pupil contracts; in dim light, the pupil expands. Cameras with automatic lenses coupled to an exposure meter operate in a fashion similar to the iris. The meter directs the lens aperture or diaphragm to open or close, in relation to the shutter speed.

A lens is commonly referred to by its largest lens opening or effective aperture. If we compare camera lenses to binoculars, eyeglasses, or rifle scopes, we observe that all have effective apertures, but the camera lens also has an adjustable aperture. These adjustable apertures are called f/stops. An f/stop is a term that represents the relationship between focal length and lens diameter.

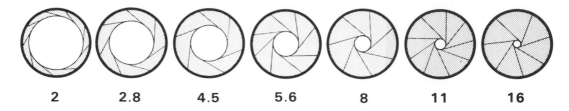

| 2 | 2.8 | 4.5 | 5.6 | 8 | 11 | 16 |

Figure 1-9 Standard Aperture Scale

A standard aperture scale shows that the smaller the f/stop number, the more light that passes through the lens. Each lens opening or f/stop admits twice as much light or half as much light as the f/stop next to it.

If you purchased a camera lens with the f/numbers or f/stops shown in Figure 1-9, the effective aperture would be f/2. This is the largest opening or fastest lens speed for a lens with a particular lens diameter and focal length. It would be called an f/2 lens.

As the effective aperture is adjusted by the f/stop ring on the lens barrel, a smaller lens diameter is produced. If the smaller diameter is divided into a fixed focal length, the resulting division

Figure 1-10 Determining F/Stop Numbers (Lens Diameter)

The size of the opening of a lens can be determined by dividing the diameter of the lens into the distance to the film plane. A 1-inch diameter in this example gives an f/2 lens opening. Closing or stopping down the lens diameter to ½ inch results in an f/4 opening. Thus, the larger the number, the smaller the lens opening.

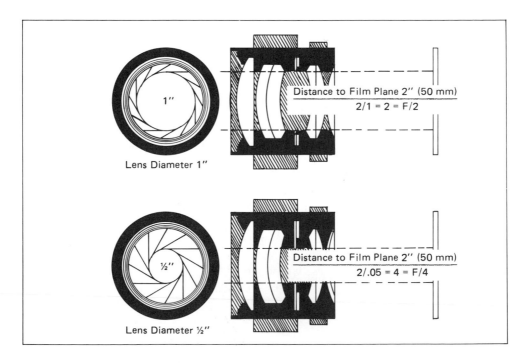

1''

Distance to Film Plane 2'' (50 mm)
$$2/1 = 2 = F/2$$

Lens Diameter 1''

½''

Distance to Film Plane 2'' (50 mm)
$$2/.05 = 4 = F/4$$

Lens Diameter ½''

produces a larger quotient. For example, our hypothetical f/2 lens has an effective aperture whose diameter in this case is one inch. By dividing this diameter into a normal 35mm camera focal length of two inches, or 50mm, the quotient is two or an f/2 lens. If the diameter is reduced to a half inch by closing down the lens and again divided into the same focal length, the new aperture is f/4—a larger number but a smaller lens opening.

Photographers refer to larger f/numbers as stopping down or closing down the lens. If more light is needed for an exposure, the photographer opens up the lens. Do not refer to opening the lens as stopping up. The proper terms are to *stop down* and to *open up.*

All camera lenses, regardless of film or camera size, are subject to the diameter/focal length relationship. This means that f/stops are universal. For example, all f/8 lens openings for normal lenses will produce the same level of illumination on the film plane. The size of the lens diameter changes in relation to the film size.

Not only does lens diameter affect the f/stop number, but changes in focal length also affect the ability of the lens to transmit light.

Figure 1-11 Determining F/Stop Numbers (Focal Length)
If a lens diameter is held constant and the focal length is changed, the effective aperture becomes smaller. In this example, a 1-inch diameter and a 2-inch focal length produce an effective aperture of f/2. If the focal length is doubled, the effective aperture becomes f/4.

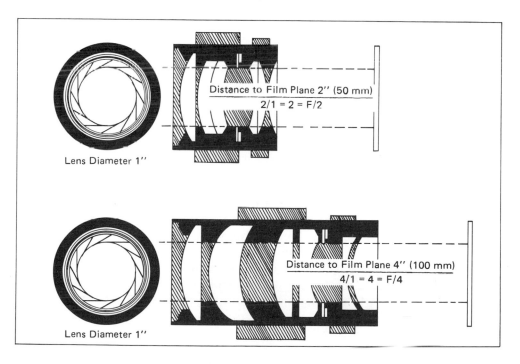

Distance to Film Plane 2'' (50 mm)
$$2/1 = 2 = F/2$$

Lens Diameter 1''

Distance to Film Plane 4'' (100 mm)
$$4/1 = 4 = F/4$$

Lens Diameter 1''

Figure 1-12 Inverse Square Law
The intensity of light varies inversely with the square of the distance from the light source. If a card is placed one foot from a light source, a certain intensity will strike the card. If the card is moved two feet from the source, the light will be one-fourth as bright (2^2 or 4). If the card is moved three feet away, the light will be one-ninth as bright (3^2 or 9).

The further light must travel through a lens to reach the film plane, the weaker in intensity the light will be, according to the principle of the *Inverse Square Law.*

The Inverse Square Law states that as the distance light travels is doubled, intensity is reduced by the square of the distance or the square of the lens diameter, if the distance is held constant. A 100mm telephoto lens whose diameter is equal to the diameter of our hypothetical f/2 lens needs four times more light to produce an image illumination level equal to the 50mm normal lens. This means that the 100mm lens must be two f/stops faster. Due to weight and cost considerations, most telephoto lenses are not made with the same or faster effective apertures as normal lenses.

Depth of Field

In addition to the factors of focal length, lens opening, and angle of view, all lenses exhibit a range of sharpness around any given focus point. This range of sharpness both in front of and behind the point of focus is referred to as *circles of confusion.* Look at a bright light source through an SLR camera. When the lens is focused sharply, the light is seen as a distinct point of light whose diameter is quite small. When the focusing ring of the lens is turned and the light source is not focused sharply, the point of light becomes a blur and appears as a circle of unfocused light. All subject matter responds the same way to the focus of a lens, whether or not it be a point of light. Subject matter focused sharply is effectively sharp. Subject matter close to the plane of the sharply focused subject matter will

appear relatively sharp. That is, the circles of confusion will be small enough to distinguish subject matter. This range of sharpness, lying about one third in front of the focus point and two thirds behind, is known as *depth of field.*

Depth of field is an important creative tool. It is used to control background sharpness, or to set a soft focus mood, or to create a strong three-dimensional effect. Control of depth of field is affected by the f/stop, camera-to-subject distance, and focal length of the lens.

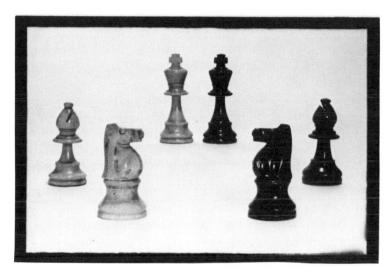

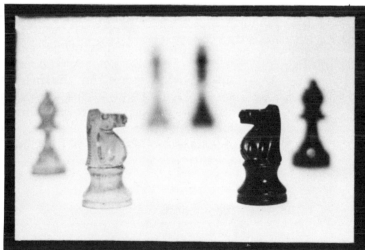

Depth of Field
These images of chessmen illustrate depth of field. Above: *Everything is sharp when the lens is stopped or closed down.* Below: *With the lens opened up, the background is out of focus.*

the f/stop

The lensless pinhole camera and the historic camera obscura, fitted with a simple optic and used by artists to trace their subject, have considerable depth of field. In a scene containing objects a few feet from the camera, as well as objects at infinity, the camera obscura sees nearly everything as sharp. As lenses became more complex in order to improve light transmission, the depth of field began to diminish. In other words, as lenses became larger in physical size and several glass elements were added, they lost the ability to provide a large depth of field, unless the smaller apertures or lens openings were used.

A lens opening of f/16, a small lens opening, has more depth of field than does the same lens when the aperture is adjusted to f/2, a large lens opening.

When a subject is being considered for its photographic possibilities, the photographer views the subject not only from side to side, but from front to back. If the photographer decides that the background should be sharp, a small lens opening (large number) is selected. If the background is seen as hindering or competing with the subject, the photographer selects a larger lens opening (smaller number).

Depth of field is difficult to control with simple, fixed-focus cameras. The effective aperture on most of these cameras is f/11, an aperture that will almost always provide a lot of depth of field.

camera-to-subject distance

Camera-to-subject distance is really a variation of image size as related to depth of field. As the camera is moved further from the subject being focused on, the image size of the entire scene becomes smaller. Doing this expands or increases the depth of field. If the camera is moved closer to the subject, image size increases, but the zone of sharpness around the point of focus is reduced. Regardless of f/stop selection, moving the camera in relation to the subject will alter the depth of field.

focal length

Lenses of different focal lengths produce different image sizes from the same camera distance. A wide-angle lens has a wider angle of view than either a normal or a telephoto lens. In order to gain more

Focal Length and Image Size
Compare the same view made with lenses of three different focal lengths. At left is a 28mm wide-angle view. In the center is the normal image taken with a 50mm lens. The view at right shows the compression and magnification of a 105mm telephoto lens. Image size changes with changes in focal length and subject distance.

picture width, the wide-angle lens produces a smaller image size. And with smaller image size comes greater depth of field. This is so because the smaller image size is equivalent to being further away from the subject, compared to other, longer focal lengths.

All lenses produce identical depths of field if the image size produced by each lens is identical. For example, a wide-angle lens at a subject distance of about 10 feet has the same depth of field that a normal lens might have at about 25 feet, or a medium telephoto lens at a distance of about 40 feet.

hyperfocal distance

When a lens is focused at infinity, depth of field extends from infinity to a point closer to the camera. Depending on the f/stop, the infinity-to-near-focus distance is called the hyperfocal distance. This means that the depth of field extends from a point halfway between the near distance and infinity. On a typical 50mm lens stopped down to f/11 with the lens focused on infinity, the depth of field is about 30 feet to infinity.

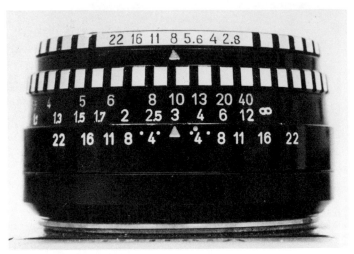

Depth of Field Scale
*Most 35mm SLR cameras have a depth of field scale located on the
lens barrel. When the lens is focused at 10 feet (3 meters) and the aper-
ture is set at f/8, the depth of field in this example will be from 7 to 20
feet. Opening the lens to f/4 with the focus remaining at 10 feet, the
depth of field is reduced to a range of 8 to 13 feet. The larger the lens
opening, the less depth of field.*

But if the hyperfocal distance of 30 feet that is read on the lens
depth-of-field-scale is now moved to the focus point, the depth of
field is now increased at f/11 from 30 feet to about 15 feet to infinity.
Be careful when using a depth-of-field scale at close distances, for
the scale is only an approximation and is subjective at best. It is
better to back up a few feet to ensure that the front focus point will
really be acceptably sharp.

TABLE 1-2 Approximate Hyperfocal Distance for 50mm Lens, in Feet*

f/4	f/5.6	f/8	f/11	f/16
70	60	55	45	30

**Distances vary with different brands of the same focal-length lens.*

the ⅓—⅔ rule

Regardless of f/stop, lenses tend to see the area in front of the point
of focus as having a shorter range of acceptable focus than the area
behind the point of focus. The ratio is approximately one third in
front of the focus point to two thirds behind. To obtain maximum

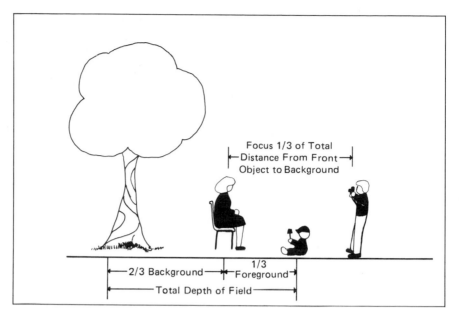

Figure 1-13 Depth of Field ⅓–⅔ Rule
Depth of field is the distance between the foreground and background points from the camera that appear in acceptable focus. A good rule of thumb for maximum depth is to focus one-third of the way into the scene and then stop down the lens.

depth of field for any subject at least six feet from the camera, determine the total distance from front to back that you want acceptably sharp. Then focus one-third of the way into this distance and stop down the lens to at least f/11. In cameras using SLR focus, the subject focused on earlier will now appear to be out of focus. Do not be alarmed. You are looking at the scene with the lens wide open, but the picture will be taken with an automatic lens whose diaphragm will close to f/11 when the exposure is made. You will not see this happen, because the viewing mirror will swing up and block your view momentarily.

depth-of-field preview

Most of the better 35mm SLR cameras are equipped with a depth-of-field preview button. The preview is an actual visualization of the information displayed on the depth-of-field scale. The image is composed with the lens wide open for easy focusing and composition. To determine whether there is sufficient focus in front of or behind the subject being focused on, a small lens opening is selected and the lens is adjusted. On automatic lenses, stopping down the lens only prepares the lens for the exposure; the visualization is still with

the lens wide open. Now, push the depth-of-field preview. The lens will close down and you will view the scene at the exposure f/stop. The image will darken, so closing and opening the preview button rapidly a few times will show you which areas of the picture will be in focus and which will not.

The preview is a handy way of gauging acceptable sharpness in your pictures as well as getting a feeling for the relative tonalities that make up your composition.

zone focusing

Many photographers use a concept called zone focusing. It is particularly useful for fast-moving subjects or when the photographer does not have time to refocus after each shot. The photographer presets the distance for a range of focus and shoots the scene only when the subject is within the preset range.

On most normal 50mm lenses, there are two useful zones of focus. One is when the focus is set at 10 feet. This gives a close focus range of about 7–15 feet when the lens is set at f/8 or smaller. The other, more useful range is when the focus is set at 25 feet. Here the zone of focus would be about 15 feet to infinity. Almost all sports activity can be handled at this distance.

The Shutter

While the aperture or f/stop regulates the size of the lens opening to let in a quantity of light, the shutter regulates or controls the length of time that the light is allowed to pass through the lens and strike the film.

TABLE 1-3 Depth of Field Suggestions

FOR MAXIMUM DEPTH OF FIELD

1. Stop down the lens and/or
2. Move back from the subject and/or
3. Change to a wide-angle lens.
4. Always focus one third of the way into the scene.
5. Check depth with the depth-of-field scale or depth previewer.

FOR MINIMUM DEPTH OF FIELD

1. Open up the lens and/or
2. Move closer to the subject and/or
3. Change to a telephoto lens.
4. Always focus on the front of the subject.
5. Check depth with the depth-of-field scale or depth previewer.

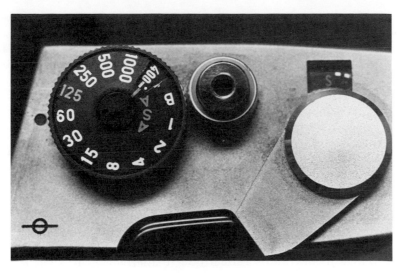

Shutter Speed Dial
A typical 35mm shutter speed dial displays whole numbers that are really fractions of a second. Also shown is the film speed (ASA-ISO) adjustment for the exposure meter.

All cameras have shutter speed. Simple cameras have only one shutter speed. In more sophisticated cameras, the shutter speed is variable, from as long as 30 seconds to as short as 1/4000 second. Shutter speeds are usually stated in fractions of a second. Most camera shutter-speed dials show whole numbers because of space problems, but these speeds are really fractions.

Shutter speeds are proportional. That is, each number on the dial represents a halving or a doubling of the amount of time that the light can pass through the lens and strike the film. If 1/30 second and 1/60 second are compared, light passes through the lens twice as long at 1/30 second than it does at 1/60 second.

the shutter as a creative tool

The shutter is often overlooked as a creative tool. But your choice of shutter speed depends on whether the subject is moving or static and the amount of available light.

Slower shutter speeds, those below 1/125 second, are often used to create a blurred effect when a subject is moving and the camera is held still. Subject motion can be arrested and the background blurred by panning the camera to coincide with the subject's movement. This is best done with shutter speeds higher than 1/125 second.

A shutter can also be held open for long exposures to reveal images not seen by the human eye, such as star trails or shadow detail in night street scenes.

types of shutters

Just as there are different camera viewing systems, so there are different shutters. A shutter mounted within a lens is called a *leaf shutter.* A shutter resembling a curtain or louvers is located at the film plane and is called a *focal plane shutter.*

A leaf shutter consists of overlapping metal blades that open from the center of the lens toward the edges. The blades are controlled through a combination of gears and springs. Leaf shutters are used in fixed-lens rangefinder cameras and in twin lens reflex cameras. They are also used in some interchangeable-lens rangefinder cameras and on some medium format SLR and large format view cameras.

Advantages of the leaf shutter include dependability and a nearly silent and vibration-free operation. However, interchangeable lenses equipped with leaf shutters are quite expensive. Due to the mechanical nature of the leaf shutter, there is a limit on fast shutter speeds, usually to 1/500 second.

A focal plane shutter is located at the back of the camera, just in front of the film plane. The shutter's action comes from a pair of overlapping metal or cloth curtains traveling horizontally, or from a set of metal blades that travel vertically.

Leaf Shutter
A leaf or blade shutter is located next to the diaphragm within the lens. A spring mechanism opens and closes a set of overlapping metal blades.

The main advantage of the focal plane shutter is that lenses do not need separate shutters. This reduces lens weight as well as cost. In addition, significantly higher shutter speeds are possible, especially with the newer electronic focal plane shutters.

Drawbacks include noise and vibration due to the movement of the camera's mirror and shutter. Higher shutter speeds are usually necessary when handholding an SLR camera, compared to cameras equipped with front-mounted shutters.

(a)

(b)

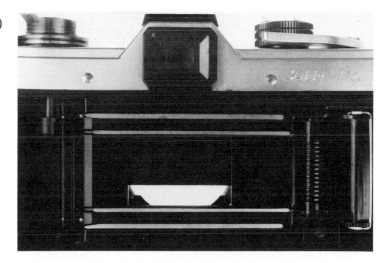

Focal Plane Shutter
A focal plane shutter is located at the film plane of most 35mm SLR and interchangeable lens viewfinder cameras. The shutter may be one of two types: (a) a horizontal curtain made of cloth or metal, and (b) a metal blade shutter that travels vertically.

2

film

All general purpose photographic films are composed of a base and a light-sensitive emulsion. The base for roll film is a flexible support made from cellulose acetate. The emulsion of black-and-white film contains fine grains of silver salts of either bromine or iodine. These salts are part of the halogen family. This means that when film is struck by short exposures of light through a lens, the silver salts or halides record an image and preserve it in an invisible state. When

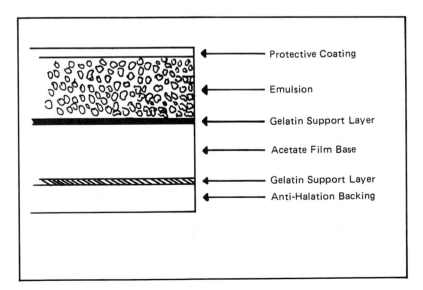

- Protective Coating
- Emulsion
- Gelatin Support Layer
- Acetate Film Base
- Gelatin Support Layer
- Anti-Halation Backing

Figure 2-1 Cross Section of Black-and-White Film
Above the acetate film base is a gelatin support layer for the silver grains suspended in an emulsion. A hard coating protects the emulsion from scratches. Beneath the base is another support layer and an anti-fog or anti-halation layer to keep light from bouncing back into the emulsion.

the film is processed in a film developer, the salts are converted to black metallic silver. The result is a visible image that is called a negative.

A negative is the reverse of the brightness levels of the scene photographed. Objects that reflect a lot of light in a scene will cause more silver salts to be exposed than will objects that reflect lesser amounts of light.

After the film is developed, objects that reflected the most light will appear darker, compared to objects that were dark originally but now appear light in the negative. These conditions are reversed when a print is made from a negative.

A Negative and a Print
A negative is the reverse of a print. Dark areas of the negative are the result of bright areas in the scene reflecting a lot of light. The light areas of the negative are the shadow or dark areas of the scene.

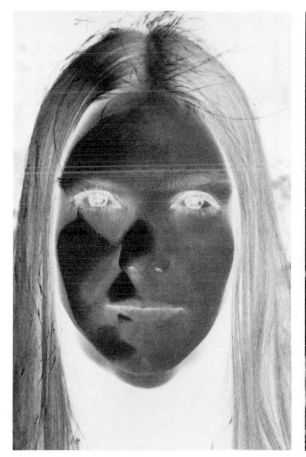
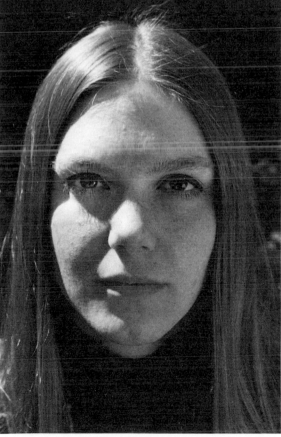

Film Characteristics

By altering the manufacturing process, many different kinds of film can be made. Some films are made for specific purposes, such as infrared or X-ray. Others are made for general purpose photography. There are several characteristics to consider in selecting a film. Some of the more important are

1. *Film speed*—the film's sensitivity to light
2. *Color sensitivity*—the response from color to shades of gray
3. *Contrast and brightness range*—the film's ability to deal with different subject contrasts and light levels
4. *Grain*—the size of the silver grains and their relationship to film speed
5. *Latitude*—the margin of error in making pictures in conditions of under- or overexposure
6. *Resolution*—the film's ability to record sharp images when enlargements are made from the negative

film speed

Film speed is a measure of a film's sensitivity to light. Films that are highly sensitive are called fast-speed films. Fast-speed films require the least amount of exposure to record an image. Films that are less sensitive to light are called medium speed or slow speed. Table 2-1 compares three black-and-white film speeds.

All films are identified by a film speed number. This number is used by the photographer to program the camera's built-in exposure meter or to set a hand-held meter. The meter will not give accurate exposure readings if the meter film speed is not matched to the film being used.

Film speed has been identified historically either by an ASA or DIN number. More recently, films are known by their ISO number.

TABLE 2-1 Comparison of Selected Film Characteristics (Panchromatic Black-and-White Film)

	FILM SPEED	CONTRAST	GRAIN	LATITUDE	RESOLUTION
Slow-speed film	ISO 25-64	High	Very Fine	½ Stop	High
Medium-speed film	ISO 80-200	Medium	Fine	1 Stop	Good
Fast-speed film	ISO 200-400	Low	Good	2–3 Stops	Fair

The ASA scale, established by the American Standards Association, is arithmetical. A film rated at ASA 400 is twice as fast as a film rated at ASA 200.

DIN stands for Deutsches Industrie Norm. It is a system used mainly in Europe and is based on a logarithm scale. An ASA 400 film is comparable in film speed to one rated at DIN 27. An ASA 200 film is the same film speed as one rated at DIN 24. A change in three digits in the DIN system indicates a doubling or halving of the film speed. Both DIN and ASA are found on film boxes and on most exposure meters.

The ISO stands for International Standards Organization. This newer system is intended to replace both the ASA and DIN ratings, although both the ASA or the DIN may appear on film boxes for some time to come. The ISO uses the same arithmetical scale as the ASA.

1. SLOW-SPEED FILM Film in this category has a film speed range of ISO 25 to 100. It is good for use in bright light when fine detail is needed. The grain structure is tight and nearly invisible, even in the large prints. Because of its limited latitude or margin of error, accurate exposure settings must be made with the exposure meter. Slow-speed films include Kodak's Panatomic-X and Ilford's Pan F.

2. MEDIUM-SPEED FILM The rating of medium-speed film falls between ISO 100 and 200. It is a film speed appropriate for many bright light conditions. There is both good grain structure and moderate exposure latitude. Kodak Plus-X and Ilford FP4 are typical medium-speed films.

3. FAST-SPEED FILM The fast-speed range is from ISO 200 to 400. This range is highly responsive in low light situations and has wide exposure latitude. Fast-speed film has a large grain structure. Prints from these negatives often appear coarse and less sharp than the slower speed films. Fast-speed films include Kodak Tri-X and Ilford HP5.

4. EXTRA-FAST-SPEED FILM Film with a rating above ISO 400 is classified as extra fast. It is used in poor lighting conditions, such as night street scenes or in dark interior scenes. Prints made from this film have a flat or low contrast appearance and are more grainy than film with slower speeds.

5. CHROMOGENIC FILM The market has seen the introduction recently of film that resembles color film in structure. Chromogenic film produces an extremely long tonal range or gray scale. This is done by using a limited amount of silver and by adding color dyes. When the dyes are blended together, the result is a long gray scale that allows for exposure at various film speeds. Film processing is done with a special color developer.

The advantage of this film is the ability to make a wide range of exposures. Almost any exposure will produce a negative that is printable. Two films of this type are Agfapan Vario X1 and Ilford XP1.

color sensitivity

In black-and-white photography, nature's primary colors of blue, green, and red are recorded as various shades of gray. Not all black-and-white film sees these colors in quite the same way. Color response is different for panchromatic, orthochromatic, infrared, and blue-sensitive film.

Panchromatic or pan film, such as Tri-X, is sensitive to all colors. It produces prints with tones similar to those that our eyes would see if the color world were converted to shades of gray. But pan films see the blue and green primaries more strongly than they do the red primary. A common result is a print with a white sky lacking in tonal detail. This can be remedied somewhat in the darkroom or by adding a filter to the camera at the time of exposure.

Orthochromatic film is sensitive to blue and green but not to red. This characteristic means that orthochromatic film can be processed under a red safelight, while panchromatic film calls for total darkness. The ability to process under red safelight makes it the preferred film for the graphics industry for the reproduction of photographs and line art.

Infrared film is highly sensitive to the infrared portion of the light spectrum. It is used in aerial mapping and in scientific and medical fields. Infrared film can produce dramatic pictorial effects, such as black skies and white tree leaves and grass.

Blue-sensitive film responds only to the blue-violet end of the visible light spectrum. It is used mainly for specialized commercial purposes, particularly for photocopying.

Comparison of Three Film Types

A street scene made on panchromatic film shows a normal rendition of a red brick building, green tree leaves, and sky.

The same scene rendered on orthochromatic film shows the bricks as black and a lighter tone in the tree leaves and sky.

Infrared film renders the foliage white and lightens red and darkens blue.

contrast and brightness range

In black-and-white photography, contrast refers to the visual difference between the darkest and lightest parts of the image. Contrast differences can be seen as differences in subject contrast, lighting contrast (brightness range), film contrast, developer contrast, and the contrast available by using various printing papers. Depending on one or all of these factors, photographs may be presented in high, normal, or low contrast variations.

High contrast refers to a limiting or compression of the photographic gray scale, making the differences between black and white more obvious. Normal to low contrast refers to an expansion of the gray scale. As the contrast is lowered, more of the subtle tonal variations are revealed.

Film emulsions are designed with different degrees of contrast to meet a wide variety of lighting conditions and subject contrasts. Graphic arts film, for example, is designed to record only black. It cannot "see" shades of color or gray. This kind of film is known as a high-contrast film.

Film designed for general purpose photography, however, must be able to translate varying reflectances or brightness ranges into shades of gray. Film with the capacity to record a wide range of gray tones is known as fast-speed film. It is inherently low in contrast. Film with a more limited gray scale is known as low-speed film and is higher in inherent contrast.

The contrast of any film depends ultimately on the inherent contrast of the film's emulsion as well as the choice of film developer and the length of time that the film is developed. Generally, film developed beyond recommended times produces negatives with greater than normal contrast. Film with shortened development times produces negatives that are low in contrast.

The relationship between film contrast and brightness range is based on individual taste. While outdoor brightness ranges can be as high as 10,000:1, no general purpose film is capable of reproducing on the negative a brightness range where the differences between highlights and shadows is greater than about 200:1.

If the brightness range of the scene is considerably greater than the inherent contrast of the film, normal exposure and normal development may not be sufficient to control highlight density and still provide adequate shadow detail. When normal exposure and normal development are the preferred or the only option, it is better to use the slowest speed film consistent with the lighting conditions and the brightness range. This means that a slow or medium speed film

Contrast Effects with Different Films
In this contrasty lighting, the contrast of the film may also be affected. At top, the scene is recorded on panchromatic film that produces a moderately contrasty image. At bottom, the same scene is rendered as extremely contrasty when exposed on high contrast orthochromatic film.

would provide a better normal exposure/normal development response to a high contrast, brightly lit beach scene than would a high speed film. Conversely, in low light or low contrast situations, normal exposure/normal development will produce more usable negatives with a fast speed film.

grain

The visible evidence of the chemical change caused when exposed silver halide crystals are converted to metallic silver grains is called grain. Under magnification or extreme enlargement, the grain structure of black-and-white film becomes obvious.

Grain is affected by film speed, exposure, development, and the degree of print enlargement.

Grain and Film Speed
Grain increases in size with increases in film speed and development time. Fast speed film (ISO 400), used at left, displays more grain with the same size image than does slow speed film (ISO 32), at right.

In order to make film more sensitive to light (increase in film speed), silver halide crystals must be large. As a result, fast speed film tends to be more grainy than slow speed film, whose silver halide crystals are smaller. Enlargements made from slow speed film generally appear sharper due to the smaller or tighter grain structure.

latitude

Latitude may be expressed as the degree to which a film can produce a printable negative given various exposure situations.

Since fast speed film has a larger grain size than slow speed film, it can accept more exposure variation, or a greater margin of error. For example, Tri-X at ISO 400 has an effective latitude of about three f/stops on either side of a normal exposure. This means that such a film could be under- or overexposed by as much as three

Latitude
Fast speed film has greater exposure response or latitude. ISO 400 film has about 2 to 3 f/stops latitude compared to about a half stop for ISO 32 film. The photo on this page was made using ISO 400 film underexposed by 3 f/stops. The photo on the next page used an ISO 32 film underexposed by 2 f/stops.

f/stops and still produce an imperfect but usable print. This is usually accomplished by making changes in development time. (See Chapter 5.)

Slow or medium speed film, with a smaller grain pattern, has more limited exposure latitude. An ISO 125 medium speed film normally does not produce a good negative beyond a one or two f/stop margin of error. Careful exposure and development is essential when using slower speed film.

resolution

Resolution is a term that describes both the optical qualities of a lens as well as a film's image definition. In film, the characteristic refers to the capacity of a film to record distinctly fine lines between adjacent subject areas. Resolution is affected by the coarseness of the grain and the thickness of the emulsion layer. Generally, fast speed film has a thicker emulsion layer than slow speed film. This means that fast speed film does not produce as sharp an image under extreme enlargement as would a slow speed film (see Table 2-1 on page 28).

3

exposure

Crucial to exposure control is the ability to relate to both the quality as well as the quantity of the available light. The former is a matter of individual response and perception. The latter is a technical decision based on an estimated exposure or the use of an exposure meter.

Qualities of Natural Light

Natural or available daylight is as variable as the seasons, the weather, and the time of day.

soft/hard light

Softer, more diffuse light is found often in the early morning hours and to a greater degree during the colder months. Light that is harder and more contrasty is found more often in the middle or late afternoon in the warmer months.

The photographer makes choices about the quality of light by choosing not only the time of year and time of day, but also location. Typically, the farther south one travels, the more brilliant and contrasty the light becomes. In addition, a drier climate also results in the light having more contrast, brilliance and sharpness.

Different Lighting Conditions

Different lighting conditions call for various metering approaches. These images of the same subject were made on different days. In figure (a), harsh sunlight produces heavy shadows and an under-exposed background unless important highlights and shadows are metered separately. In figure (b), made under cloudy bright conditions, metering from the camera position often produces a good image. In figure (c), made under heavy contrast, slight underexposure and overdevelopment are needed to provide better subject contrast and background separation. In figure (d), made under open shade, a close-up reading of the highlights brightens the image.

(a)

(b)

(c)

(d)

sun and weather

Sun and weather conditions also affect the quality of the light. Film manufacturers base their exposure recommendations on weather conditions.

Sun conditions for photographic purposes are:

Bright or hazy sunlight—usually 10 a.m. to 3 p.m. on a clear day

Cloudy bright—brilliant light with an absence of shadow

Heavy overcast—flat or low contrast and the absence of direct sun

Open shade—sunlight does not fall directly on the subject

"feel" of the light

While there is no formula for judging the quality of light, a photographer often deals with the light by "feel." If the light "feels good" it can do marvelous things for the subject. The light, for example, may reveal brilliance or texture. It may provide good separation of subject from background, particularly in backlighting. The light may also create visual "highs" or somber "lows." The lighting mood is what we are after. Proper exposure and subsequent film development can help recreate that mood on the print.

Aperture-Shutter Relationship

Before making exposure decisions, the aperture-shutter relationship must be understood. In Chapter One, both the aperture and shutter functions were explained. To review, the aperture or lens opening is designated as an f/number, such as f/2 or f/16. The smaller the f/number, the larger is the lens opening. Adjustable lens openings allow exposure control and control over depth of field.

The shutter is a means of limiting the time that the light will pass through a preselected lens opening. Shutter speeds are variable, ranging from slow speeds, such as one second, to fast speeds, such as $\frac{1}{1000}$ second. Each number on the shutter speed dial is double or half the time of the number next to it.

The photographer must choose an f/number or f/stop and shutter speed combination most appropriate to the lighting situation and the need to control depth of field or subject motion. The exposure combination selected is called equivalent exposure.

equivalent exposure

An adjustable lens permits a doubling or a halving of the volume of light passing through the lens opening. The shutter doubles or halves the time the light strikes the film. Therefore, in terms of exposure, f/stops and shutter speeds are interchangeable. Any correction or adjustment made to a lens opening can be compensated for by a change in shutter speed.

To be able to make equivalent exposure adjustments, a base exposure must first be determined. We recommend for 35mm cameras that the base exposure should start with a $\frac{1}{125}$ second shutter speed. This speed is usually the minimum speed necessary to avoid camera movement during exposure. In addition, slight subject movement can also be arrested.

In the following example, an exposure meter reading or exposure estimate calls for an exposure of $\frac{1}{125}$ second at f/11. Any of the exposures listed below are equivalent exposures. That is, they will all produce identical negative densities.

Hypothetical Equivalent Exposure

Shutter Speed	1/30	1/60	1/125	1/250	1/500	1/1000
F/Stop	f/22	f/16	f/11	f/8	f/5.6	f/4

If there is a need for shutter speeds faster than $\frac{1}{125}$ second in order to stop action, the lens is opened as many stops as shutter speeds were increased. If more or less depth of field is desired, the shutter speed is adjusted to increase or lessen the time of the exposure, according to the f/stop used.

Equivalent exposure is an important concept, even if the camera is to be used in an automatic metering mode. The photographer must still make an exposure decision based on the need to stop or to blur subject motion and to control depth of field.

Estimating Exposure

If an exposure meter is unavailable, general exposure estimates can be made in one of three ways—from a film speed exposure formula, from exposure guides provided by the film manufacturer, or by bracketing.

Film Speed Formula Film speed as set by the manufacturer is somewhat adjustable depending on conditions of exposure and de-

TABLE 3-1 Outdoor Exposure Guide for ISO 400 Film

SHUTTER SPEED 1/500 SECOND	SHUTTER SPEED 1/250 SECOND			
Bright or hazy sun on light sand, snow f/22	Bright or hazy sun (distinct shadows) f/16*	Cloudy bright (no shadows) f/11	Heavy overcast f/8	Open shade f/8†

*Between f/8 and f/11 for backlighted close-up subjects
†Subject shaded from sun but lighted by a large area of sky

velopment. But the film speed can be a clue to exposure by relating film speed to time of day and sun conditions. This is expressed as a film speed value: 1/ISO at f/16 at noon on a bright sunny day. If the film speed fraction is converted to a shutter speed, an exposure estimate can be made. For example, if ISO 400 film is used in the formula 1/ISO at f/16, the shutter speed would be 1/400 second at f/16. Most cameras do not have 1/400 second shutter speed so the nearest shutter speed is used—either 1/250 or 1/500 second. As the light intensity weakens, more exposure may be needed. (See Table 3-1.)

Outdoor Exposure Guide Most film manufacturers provide an exposure guide with their film. Table 3-1 is an example based on ISO 400 film. The exposure guide is for average subjects or those scenes where there are no large or dominating areas of brightness or darkness. Using the guide gives exposures accurate enough to produce a good negative with normal development. Equivalent exposures can be made from any exposure combination selected from the table.

Bracketing If the exposure estimate is uncertain, bracketing the exposure usually provides at least one good negative. First, make an exposure using an estimate from the film speed fraction or from the exposure guide. Now make two more exposures, first by opening up the lens two f/stops from the original estimated exposure and then by closing down two f/stops. The result is three different exposures of the same scene, one of which will probably produce a good negative.

Metering for Exposure: The Middle Gray

Exposure meters are designed to read a value based on 18 percent of all the light falling on the subject or 18 percent of the light reflected from the subject. This 18 percent reflectance or middle gray represents the middle of the exposure scale that ranges from solid black

to pure white. The system is based on the fact that white objects reflect about 90 percent of their value, while black objects reflect as little as 3 percent. The average of this reflectance is 18 percent or middle gray.

In practice, if an exposure meter is aimed at a white surface, a normal print made from that exposure will produce a middle gray shade or tone. If a meter is aimed at a black surface and a normal print is made from that entirely different exposure, the result will still be a middle gray tone on the print. Since most scenes are rarely all white or all black, an average exposure between these extremes produces various densities on the negative that print as shades of gray and black and white.

Types of Exposure Meters

Exposure meters that measure the light reflected from a subject are called reflected light meters. Those that measure the light falling on the subject are called incident light meters.

reflected light meters

Reflected light meters are usually included as built in original equipment on most new cameras. However, many serious photographers also use hand-held meters.

Reflected Light Meter
A reflected light meter measures the amount of light reflected from the subject. The meter is aimed at the subject from the camera position.

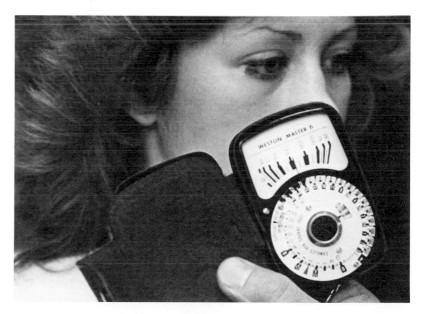

Built-in meters measure the light passing through the camera lens or through an optical sensor on some fixed-lens cameras. The exposure information is displayed in the viewfinder and is also conveyed to the aperture and shutter speed functions on cameras with automatic exposure systems.

spot meters

Spot meters are hand-held meters that measure light reflected from a small portion of a scene. Most reflected light meters measure over an angle of about 40 degrees. The spot meter reads a narrower angle of view, from about one to three degrees. Measurements are made from key areas of the scene, such as highlights or shadows. Exposure is then estimated from this information.

incident light meters

Incident light meters use a special white diffuser to cover the photocell. In this method, a reading is taken of the light falling on the subject. To do this, the meter is aimed at the camera position from the subject position. The meter averages the light falling on the subject and disregards what is being reflected from the subject. These meters are used commonly in motion picture work and in commercial studios to establish the lighting placement. Some reflected light meters can read incident light by placing a special diffuser over the photocell.

Spot Meter
A spot meter measures the light reflected from a small area of the subject.

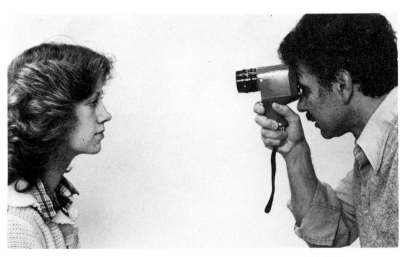

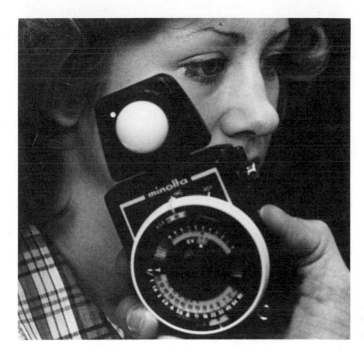

Incident Light Meter
An incident light meter measures the amount of light falling on the subject.

built-in meters

During the past decade, internal or built-in metering has proven itself. Buyers are now presented with a bewildering array of exposure systems. The following are the most common:

1. SHUTTER PRIORITY METERING Select a shutter speed and the meter adjusts the lens opening for the average brightness of the scene. The advantage is simplicity. Using the suggested shutter speed of $1/125$ second, the meter will take care of probably 80 percent of all shooting situations. The disadvantage is that focus has to be highly selective since depth of field will vary greatly depending on the lens opening the meter selects.

2. APERTURE PRIORITY METERING Select a lens opening and the meter automatically selects the shutter speed. The advantage is better control over depth of field. The disadvantage is that the shutter speed may not be fast enough to stop action or to avoid camera motion.

3. CONVERTIBLE EXPOSURE PRIORITY Changes in exposure may be made from both the shutter speed or the lens opening. This system provides the greatest flexibility in controlling action and depth of field. But too many options tend to confuse a beginner. Costs of this system are greater than for single mode metering.

4. MANUAL OVERRIDE Most good 35mm SLR cameras have built-in override capacity in their metering systems. This means the photographer can take advantage of the camera's built-in metering or change exposure to meet a variety of shooting situations.

power sources and weighting

Exposure meters are made light sensitive through one of four current chemical/electrical sources: selenium, cadmium sulphide (CdS), silicon blue (Scb), or gallium arsenic phosphide (GAP).

Selenium Most inexpensive meters that do not require a battery power source are powered by a light-activated selenium cell. The cell generates electricity through light, causing a needle to move across a gauge. The meter works well in bright light, but is relatively weak or ineffective in low light.

Cadmium Sulphide (CdS) This popular battery-driven system combines a light-sensitive semiconductor cell with a long-life battery to power the meter. The CdS is good for reading low light levels. This system has one disadvantage—a "memory" when moving from bright to dark lighting situations. It tends to remember its former reading for some time before adjusting to a new lighting situation. It is best to wait about a minute before taking new readings.

Silicon Blue (Scb) This cell produces little electricity but is highly sensitive in low light. A battery is necessary to power the cell. Unlike CdS, silicon blue has no memory.

Gallium Arsenic Phosphide (GAP) This cell is similar to silicon blue except that it is not sensitive to infrared radiation. GAP also uses a battery.

Built-in meters use generally only a portion of the prism viewing area for the actual metering. Meters may be, for example, center-weighted, spot, averaging, or provide an overall reading off the shutter curtain. It is best to check the camera's instruction manual to avoid improper readings.

Any decision to buy a meter or a camera/meter system should always take into account how the meter is to be used most often. Remember that battery operated meters do not operate accurately in cold weather. Also, silver oxide batteries that are standard for camera meters do not lose their life slowly, but can "die" unexpect-

edly. Batteries should be changed at least once a year to avoid the loss-of-life problem and corrosion.

For most beginners, a CdS averaging meter is sufficient, as long as the "memory" problem is kept in mind.

Selective Meter Readings

Scenes that include predominantly bright areas (above middle gray) or large dark areas (below middle gray), usually require interpretation. This technique may be used with either hand-held or built-in meters.

Bright Skylight Landscapes often contain too much bright sky. In this case, if an average meter reading is made, or the meter is tilted slightly toward the sky, a loss of detail may result in the shadow or ground portions of the scene. By tilting the meter or camera downward slightly, a more normal exposure may result. Another method is to identify a large area that approximates middle gray, such as green grass, and meter the exposure for that.

Bright Skylight
If an outdoor scene contains too much bright skylight, inaccurate meter readings may cause the foreground to be underexposed (below). Tilt the meter slightly downward to correct the problem (see next page).

Bright Objects, Dark Background
Extremely bright reflectances from foreground objects can sometimes cause a background to be underexposed. Take separate meter readings of both foreground and background and average the difference.

Bright Objects Against Dark Background Normal meter readings may cause the background to be underexposed. One approach to rectify this is to take readings of both the highlights and shadows and "average" the exposure between these extremes.

Backlighting When subjects are backlighted, move in close to read the shadow detail. If a typical average reading is made, the foreground becomes a silhouette. If the meter cannot be moved in close, open up the lens one or two f/stops beyond the average reading.

Backlighting
Backlighted subjects metered from the camera position call for an overexposure of one or two f/stops to avoid turning the subject into a silhouette.

Palm Method When it is impossible to walk up to a subject to make a reading, the palm or hand method can be of some value. Make sure your hand is lit by the same intensity of light as that falling on the subject. Then open up one f/stop from the reading made from a Caucasian hand, or stop down one f/stop from a reading made from dark or black skin. Remember, an exposure meter is designed to respond to 18 percent of the light reflected from the subject. Caucasian skin reflects about 36 percent of the light falling on it, while black skin reflects about 9 percent. If the meter is not corrected from the palm reading, under- or overexposure will result.

Gray Card Many photographers use an 18 percent gray card for general metering. The card is held in front of the scene. The light reflected from the card is measured. Since the card and the meter are both matched at 18 percent reflectance, no exposure adjustments are necessary.

Gray Card
Separate meter readings of highlights and shadows are unnecessary when an 18 percent reflectance gray card is held near the subject and metered. A reading obtained from the card is the average of all the light falling on the subject.

Palm Method
When it is impossible to meter close to the subject, the palm method can substitute for a gray card. Take a meter reading of the light falling on the palm. Be sure to open up the lens one f/stop from the indicated exposure for light skin tones or stop down one f/stop for dark skin tones.

Exposure and Development Relationship

Chapter 5 is concerned with film development and negative quality. Yet no discussion of exposure using black-and-white film is complete without looking at the relationship between exposure and development.

Many lighting situations do not contain large bright or large dark areas that must be dealt with selectively. Under average conditions, normal exposure and normal development provide a negative of proper density and contrast.

When photographers depart from normal exposure, the decision is usually based on the need to include shadow detail. If detail is desired in the shadows, the film must be exposed for the shadow detail in order to provide sufficient density on the film. Without sufficient density, the ability to hold shadow detail on the print is impossible.

When film is exposed for the shadows, highlight details tend to become overexposed. This means that too much silver is being exposed in the highlights. If the film is developed normally under these conditions, the highlights will be too dense as a result of overexposure and too contrasty as a result of overdevelopment. To compensate, photographers reduce development time. Since shadow details stop development first and dense areas or highlights continue to develop for a longer period, restricting development time is a way of controlling highlight density.

Two basic rules for making changes in contrast are:

1. In bright, contrasty light using fast film: *overexpose and underdevelop*. If the overexposure is one f/stop, then cut development time by about 20 percent.
2. In flat, overcast light using fast film: *underexpose and overdevelop*. If the underexposure is one f/stop, increase development time by 50 percent.

The overall contrast of the scene is thus raised or lowered by changes in development time. Keep in mind that changes in exposure are really changes in film speed. If an ISO 400 film is overexposed by one f/stop, the real film speed value is changed to ISO 200. Development time is then adjusted for the new film speed.

When using 35mm or roll film, the entire roll should be exposed under similar lighting situations. In this way, the meter may be programmed for a new film speed. The exposed film is then marked for the new film speed so that development time can be changed.

If lighting situations are drastically different, say bright sunlight and flat light all on the same roll, changes in development time may work with some negatives but not with others.

4

filters

The primary colors of white light are red, green, and blue. Panchromatic black-and-white film records these colors as various shades of gray. Filters are used to subtract some portion of the red, green, and blue primaries. This is necessary for purposes of color correction, changes in contrast, haze control or for polarizing to minimize glare or reflections.

Other filters are used for special effects, such as star patterns or multiple images. These have no influence on subject coloration.

Filters are constructed from either optical glass, plastic, or gelatin. Glass filters have a threaded ring that allows the filter to be screwed into the lens flange. Plastic or gelatin filters are usually fitted into a filter holder that is attached to the lens.

How Filters Work

When a colored filter is placed in front of a camera lens, some of the light that would normally reach the film is absorbed by the filter. If a red filter is used, for example, most of the blue and green primaries will be absorbed by the red filter, leaving mostly red spectrum light waves to reach the film. This means that the negative receives minimum amounts of blue and green light waves and heavy amounts of red.

When reviewing a print made from a negative exposed through a red filter, blue and green appear darker than normal and red ap-

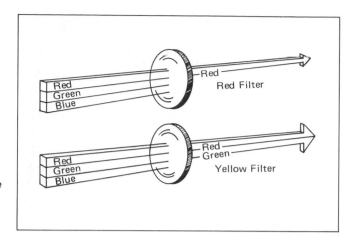

Figure 4-1 How Filters Work
In these drawings, filters are shown absorbing some primary colors, while allowing others to reach the film. The yellow or K2 filter passes red and green while absorbing blue. The red or 25A filter absorbs blue and green and passes its own color.

pears lighter than normal. The general rule for deciding what filter to use when photographing with black-and-white film is that *a filter lightens its own color on the print.*

filters for correction

Panchromatic film is much more sensitive to blue, ultraviolet, and green wavelengths than it is to red. This means that in a scene containing a great deal of blue sky and green trees or lawn, panchromatic film records the sky and trees more heavily on the negative

Panchromatic Film without a Filter
Absence of a blue sky is the most obvious deficiency of this print, made without a filter.

Yellow Filter
Use of a yellow filter shows in the effect on the sky and in the lighter shade of green grass. The walls of the house, which are painted green, are rendered lighter with a yellow filter in front of the lens.

than would be perceived by the human eye. A print made from the negative would show a white sky and trees with lighter than normal foliage.

A correction filter is used to absorb or subtract some of the blue, ultraviolet, and green wavelengths in order to darken the sky and foliage on the print. The most common correction filter is the medium yellow K2 filter. It is used to bring a more normal visual balance to the film. The yellow filter is composed of both green and red primaries. These colors are passed to the film, while most of the blue and ultraviolet and some of the green are absorbed by the filter.

The medium yellow filter is the best general purpose landscape filter to use with panchromatic film. Skies are rendered darker, which brings out the cloud detail. Foliage is darkened moderately to provide more separation between various shades of green.

filters for contrast

The photographer sometimes wishes to emphasize certain colors for greater contrast in a scene. Typical contrast filters are the orange or 15(G) filter, red or 25(A), and green or 11(X1) filter.

The orange filter is used to achieve deeper sky color and more separation of tones in the green and red primaries.

Green Filter
A green filter darkens the sky and lightens the color of the grass. The effect is most noticeable on the green walls of the house.

Red Filter
The most dramatic effects come from the use of a red filter. The sky is almost black, the grass is darker in tone, and the overall contrast of the scene is more extreme.

The red filter provides the most dramatic contrast. Skies become almost black, foliage is richer in tone, and red is rendered as a light gray.

The green filter lightens foliage and grass. It gives the sky a good medium gray tone and turns red into black. This filter is sometimes used for outdoor portraits of men because it gives a ruddy look to the skin. If this filter were used for portraits of women wearing heavy makeup, the results would be exaggerated. Too much lipstick could show as black in the print.

filters for reflection and haze

Problems with glare and reflection can be brought under control by using a polarizing filter. The filter is gray in color and is composed of two pieces of polarizing glass fitted together in a single threaded ring. When one filter in the pair is rotated, light that is not at 45 degrees to the plane of the lens is blocked, leaving the reflection behind. The filter is especially useful when photographing storefronts or water scenes.

Haze in the form of ultraviolet radiation is not as visible to the eye as it is to panchromatic film. Distant mountain views are often unprintable because of the haze. A light pink filter, variously called a haze, ultraviolet or skylight filter, reduces the haze and provides more contrast with longer telephoto lenses.

A haze filter can be left on the camera to protect the lens. Neither color nor exposure are affected with the filter left in place.

Fitting Filters to the Camera

Filters may be attached to the camera in one of four ways:

1. Using a threaded adapter ring that screws into the lens flange. This is for filters having an unthreaded band.
2. Using a threaded filter matched to the lens barrel threaded flange.
3. Using a filter drawer attached to the lens. The drawer allows the use of plastic or gelatin filters or special effect filters.
4. When none of the above are available, a camera may be placed on a tripod and a large filter can then be held in front of the lens.

It is always best to use a lens shade when taking pictures. The shade acts like a hat brim in sunlight, reducing the glare and adding contrast to the scene. A lens shade can be used with a retaining ring or threaded directly into the lens flange.

Exposure Adjustments

Since filters subtract a portion of the light that would normally reach the film, exposure corrections must be made.

Cameras with built-in metering systems automatically correct for the loss of light when a filter is used. However, metering systems vary with the camera. It is best to check the instruction manual.

Cameras lacking internal metering systems must be adjusted after a basic exposure is determined. The amount of exposure increase depends on the filter's coloration. This is converted into a factor or multiplier.

Every filter is given a factor by the manufacturer. For example, a medium yellow K2 filter is normally assigned a factor of 2. This means that the exposure must be multiplied by a factor of 2. The lens opening or shutter speed is then adjusted from the basic exposure to allow one additional f/stop of light to reach the film. If the basic exposure called for an f/11 lens opening and a shutter speed of $\frac{1}{125}$ second, the lens would be opened to f/8 when the filter is used.

Factors for the most common filters include: medium yellow—2, orange—2.5, green—4, red—8 and a polarizer—4/8, depending on the amount of polarizing. Refer to Table 4-1.

TABLE 4-1 Exposure Adjustments for Black-and-White Filters*

FILTER	EXPOSURE FACTOR	FILTER EFFECT
No. 8(K2) Medium Yellow	2 (Open lens 1 f/stop)	Darkens sky and renders scene normally.
No. 15(G) Orange	2.5 (Open lens 1½ f/stops)	Darkens sky, penetrates haze slightly when using telephoto lens.
No. 11(X1) Green	4 (Open lens 2 f/stops)	Darkens red and blue, lightens green.
No. 25(A) Red	8 (Open lens 3 f/stops)	Dramatic darkening of sky and water, lightens red, darkens foliage.
Haze, UV, or Skylight	No exposure adjustment	Darkens sky by absorbing UV radiation.
Polarizer	2–4 (Open lens 1–2 f/stops)	Darkens sky, reduces glare and reflections.

Factors differ slightly for tungsten indoor light sources. See filter instruction sheet or Kodak Master Photoguide.

5

film development

The moment the photographer clicks the shutter an image has been recorded. This image remains in a latent or invisible state until the film is developed.

Since any color of light affects panchromatic film, preparing the film for development must be done in total darkness. The most common method is to use a light-tight developing tank and loading reel.

The film is first removed from the camera. In total darkness, the film cassette is opened. The film is then placed on a grooved developing reel in order to allow the liquid chemicals to reach the film emulsion. After loading, the film reel is placed in the developing tank and a light-tight lid is placed on the tank. The remainder of the developing process may be done with the room lights turned on.

Chemicals Needed

The following chemicals are necessary for film development: developer, water or acid stop bath, fixer, clearing solution, and wetting agent. These chemicals are available as ready-mixed powders or liquids.

film developers

The first and most important chemical in the development process is the developer. A developer is a mixture of several chemicals formulated to convert the exposed silver halide crystals to black metallic silver.

Developers usually contain a developing agent, a preservative, an accelerator, a restrainer, and water, which acts as a solvent.

Some common developing agents are metol (also trademarked as Elon) and hydroquinone. Metol is used as a low contrast developing agent. Hydroquinone is used as a high contrast agent. Kodak's D-76, an excellent general purpose developer, is a combination of both metol and hydroquinone.

Preservatives are added to prevent loss of developer strength through oxidation. They increase solvent action and help produce fine grain. Sodium sulphite is a popular preservative.

An accelerator, such as borax or sodium carbonate, controls the rate of development.

A restrainer is added to the developer to control overdevelopment of the film. Without a restrainer, the film might produce an overall gray tone known as chemical fog. Potassium bromide is a common restrainer.

Film developers can be divided into four categories: general purpose, fine grain, acutance, and high energy.

General Purpose Developers Developers such as Kodak's D-76 are recommended for many films. They produce medium fine grain and maximum film speed, but with limited shadow detail.

Fine Grain Developers Fine grain describes a quality of smoothness in the negative, especially in untextured areas like the sky. The effect is like one of sandpapered wood, where the general softness of the sanded wood reveals the subtlety of the wood grain, but not the sharpness of the texture. Thus silver grains are "sandpapered" on their edges by chemicals that gently dissolve silver. A fine grain developer may not be the best choice where maximum sharpness and clarity of detail is needed.

Depending on the amount of dilution with water, Kodak Microdol-X and Edwal FG-7 are considered fine grain developers.

Acutance Developers These developers are capable of producing negatives with great sharpness but a more grainy appearance. One of the most time-tested of the acutance developers is Rodinal. Acutance developers contain few or no chemicals that act as solvents on the silver grains.

High Energy Developers These developers are also called "compensating" developers because they tend to work more slowly in the heavier or denser parts of the negative. The result is more control

over contrast, particularly in contrasty lighting situations. Shadow detail can be increased by using extended developing times and weak solutions of a high energy developer.

Kodak HC-110, Edwal FG-7 (in strong dilution), and Rodinal are examples of high energy developers, depending on the dilution and changes in development time.

Whatever developer is chosen, the best recommendation is to stick with it for an extended period of time. The same advice can be extended to film. Pick a film and developer combination such as Tri-X and D-76 and learn from experience what is and what is not possible from the combination.

stop bath

When using film developers that contain a large amount of sodium carbonate as an accelerator, a stop bath containing a 28 percent solution of acetic acid will be needed to neutralize the alkalide carbonate. This condition is more common with sheet film developers than it is with 35mm or roll film developers. Most small format film developers do not contain a carbonate accelerator, so water can be used instead of a stop bath. If the film developer used calls for an extremely short developing time (2 to 3 minutes), an acid stop bath is recommended.

fixer

After the stop bath treatment, the film is immersed in fixer, sometimes called "hypo." This is a compound of sodium thiosulphate or ammonium hyposulphite. Fixer removes unexposed silver halides, halting development completely. It is better to use a fixer that contains a hardening agent, such as alum. The hardener makes the film emulsion more resistant to scratches.

clearing bath

After the film is fixed, it is washed briefly and then immersed in a clearing bath. The bath contains a solution of hydrogen peroxide and ammonia. Depending on the manufacturer, the clearing bath is also called hypo eliminator or hypo clear.

The clearing bath changes the fixer to a compound which is more soluble in water. The result is a shortened washing time as well as more complete neutralizing of the fixer than if the film were washed for long periods of time.

wetting agent

Following a thorough washing of the film in water at 68°F, the film is immersed in a wetting agent to prevent it from water spotting as it dries. Kodak's Photo-Flo is a typical wetting agent.

Film Developing Equipment

Developing Tank and Reel There are three types of film developing reels. Each has its advantages and disadvantages.

1. PLASTIC APRON The plastic apron film reel is the easiest to load and to use. The apron contains a closed circle at one end. The film is inserted at the point of the closed circle. Then the apron and film are simply rolled or wound together. The apron has a series of evenly spaced bumps along the top and bottom of the strip to allow the developer to make contact with the film emulsion. Once the film is loaded, the apron is inserted into a plastic or metal tank.

Advantage: Film-loading method is foolproof.
Disadvantage: The apron is weightless and may cause uneven development when agitating the film.

2. PLASTIC REEL Plastic reels require only a little practice in order to load the film properly. Most plastic reels are described as self-loading. The film is loaded from the outside edge of the spiral by turning the two ends of the reel in opposite directions. Tiny ball bearings grip and guide the film toward the center of the reel.

Developing Tanks and Reels
Developing tanks and reels for 35mm and roll film are of stainless steel or plastic construction. Metal reels and tanks are more durable but are more difficult to use. Plastic aprons are sometimes used as a substitute for a reel and are easy to load.

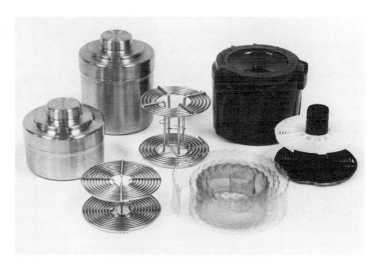

Advantage: Easy to load. A single reel adjusts for different film sizes, thereby cutting cost as well as the need for several reels.

Disadvantage: The chief problem is with the film agitation method. The light-tight lid usually contains a rod which is used to spin the film in the developer. By turning the rod too fast or unevenly, this agitation method may cause uneven development or overdevelopment. Plastic reels can also wear rapidly, making the self-load feature a liability as the plastic weakens with age and use. Dropping a plastic reel may cause it to break or chip. Reels must be absolutely dry before reloading.

3. Stainless Steel Reels The stainless steel system is at once the best and the most difficult to load in the dark. But the potential for long wear and more even development makes this system the best. Steel reels are loaded from the center. They require practice in room light with dummy film. Reels and tanks come in various sizes, which allows for development of more than one roll of film at a time.

Tank sizes are: 32 oz.—Holds four 35mm reels or two 120 reels.
16 oz.—Holds two 35mm reels or one 120 reel.
12 oz.—Holds one 35mm reel.

For 35mm developing, it is best to buy one 16 oz. and one 12 oz. tank as well as two or three reels.

The metal tank consists of a container, a light-tight lid, and a cap. The cap is needed in order to agitate the film by the inversion method.

Advantage: By far the most even and efficient agitation method. The tanks and reels are extremely long-wearing. The system allows for developing more than one roll of film at a time. The reels may be reloaded even if not completely dry. Reels and tanks can be easily cleaned.

Disadvantage: Requires practice before loading. Film can be bent in loading, causing "half moon" crimp marks on the negative. Film layers may stick together if not loaded properly, causing loss of those images. While the reels are more sturdy than plastic, dropping a reel may bend the thin metal spirals, or cause a weld to come loose.

35mm Film Cassette Opener Commercial cassette openers are available, but a bottle opener will do. Roll films do not require a special opener.

Thermometer A good photographic thermometer is essential. Dial types, such as Weston or Brooks, are recommended.

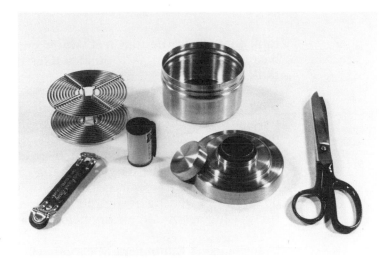

Film Loading Equipment
Equipment needed for film loading includes a film reel and tank, cassette opener, and scissors.

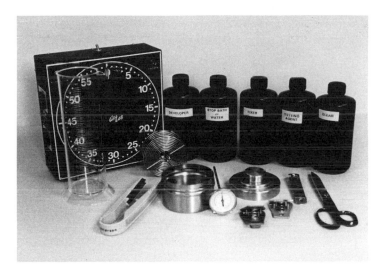

Developing Equipment and Chemicals
Equipment needed to complete the developing procedure includes a measuring beaker, timer, thermometer, cassette opener, scissors, film squeegee, and film drying clips. Chemicals include developer, stop bath or water, fixer, clearing agent, and wetting agent.

Timer A reliable timer is needed, since a variance of 15 seconds can change the development characteristics of a negative. A mechanical timer, such as a General Electric, or the electric Gralab is recommended.

Beakers or Graduates Pint- or quart-sized beakers, sometimes called graduates, are necessary to measure correct amounts of liquid chemicals.

Washer Tank Film may be washed directly in the developing tank, or by the use of pressure washers. The pressure washer is a plastic

tank that holds the film reel. Water enters under pressure at the base, being aerated as it pushes fixer up and over the top of the tank.

Squeegee or Sponge Squeegee tongs with rubber blades do the best job of removing excess moisture from the film. The tongs should not be squeezed too hard so as not to scratch the film. Tongs should be dipped in wetting agent first to reduce chances of scratching. After using, wash the tongs and hang to dry.

Another type of squeegee is made of sponge. The sponge should be dipped in wetting agent and squeezed dry before use. Wash out the wetting agent and air dry before storing in a clean container.

Miscellaneous Equipment Scissors will be needed to cut the 35mm film leader before loading. Following the processing procedure, film will be hung to dry. Film clips or clothespins are used for this purpose. Finally, negative storage sleeves are needed to protect the negatives from scratches and dust.

Preparing the Chemicals

The first step in film processing is to prepare the needed chemistry before turning off the lights and beginning the film loading procedure.

The preparation of each chemical varies with the brand. Consult the mixing instructions printed on the package. Most powdered chemicals will need to be mixed with water at temperatures higher than the 68° F necessary for film processing. Therefore, mixing should take place several hours earlier to allow the chemicals to cool and to thoroughly dissolve.

A total of five working solutions are prepared: 1) film developer, 2) water or stop bath, 3) fixer, 4) clearing solution, and 5) wetting agent.

1. FILM DEVELOPER For purposes of explaining film development preparation, we will describe the procedure used with Kodak D-76, a standard general purpose film developer.

A quart package of D-76 is dissolved in water at 100° F to make one quart of stock solution. This solution is stored in a brown bottle to avoid light oxidation of the developer.

The instructions on the package may say: "To use the developer,

mix one part of stock solution with one part water at 68° F." This will provide a working solution in a dilution ratio of 1:1.

If one roll of 35mm film is to be developed and a single-reel steel tank is used, the working solution of D-76 will be 6 ounces of stock solution and 6 ounces water.

2. WATER BATH OR STOP BATH Next prepare 12 ounces of water in a beaker at 68° F. An acid stop bath is not normally necessary for roll film, but is usually used with sheet film.

3. FIXER Into another beaker, pour 12 ounces of fixer. This is used straight for film. No dilution is necessary. Do not throw away the fixer after use. Several rolls of film may be run through the solution.

4. CLEARING SOLUTION In another beaker, prepare a working solution of clear. Kodak's clearing solution calls for a dilution of 1:4. This means that one part of clearing solution is mixed with four parts water at 68° F. In a 12-ounce tank, this means 2½ ounces of clear and 9½ ounces of water.

5. WETTING AGENT The final solution is the wetting agent. This can be prepared after the film is washed. A drop or two of Kodak's Photo-Flo or other brand is added to clean water in the tank.

Loading the Film

Before turning off the room lights to load the film in complete darkness, review the processing steps as shown in Table 5-1. Set the film developing time according to the suggestions shown in Table 5-2.

Once the lights are turned off, open the film cassette and push out the film. Hold the film in the palm of your hand to keep it from unwinding. Take the scissors and cut off the film leader.

A standard steel developing reel is built in spiral fashion. Hold the reel in your left hand and feel for the ends of the spiral. They should point toward your right hand. If you are left-handed, simply reverse the position of the film and reel. To repeat, the open end of the spiral must point toward the film. If the spiral end is facing away from the film, it will be impossible to load the film properly.

Put the reel on the counter for a moment and extend the film three or four inches so that it can be curved slightly between your thumb and forefinger. Now pick up the reel and insert the curved

TABLE 5-1 Steps in Film Developing for 35mm and Roll Film

CHEMICALS/PROCESS*	TIME/AGITATION
1. Load film on reel in total darkness. Place reel in tank, place lid on tank. Turn on lights.	Follow manufacturer's recommendation for time and dilution of developer
2. Set timer	Agitate continuously for 15 seconds and then for 5 seconds every 30 seconds
3. Add film developer	
4. First water or acid stop bath	15–30 seconds continuous agitation
5. Fixer	5 minutes initial agitation
6. Second water bath	10 seconds with agitation
7. Clearing agent	2 minutes, brief agitation
8. Wash with running water	5 minutes
9. Wetting agent	15 seconds, no agitation
10. Remove film from reel and squeegee excess moisture	
11. Hang to dry with weighted film clips	
12. Cut negatives and place in sleeves	

*All chemical and water steps at 68° F

TABLE 5-2 Suggested Developing Time for 35mm and Roll Film Using D-76 1:1 at 68° F

FILM SPEED	TIME
ISO 32	7 minutes
ISO 125	7½ minutes
ISO 400	9–10 minutes*

*Roll film should be developed for 10 minutes

end into the clip or open space in the center of the reel. Now move your thumb and forefinger along the film edges until the fingers are touching the edges of the reel.

With a smooth motion, turn the film down on the reel so that it begins to slide into the grooves. Keep your fingers on the edges of the reel and begin turning the reel. This will feed the film into the reel.

Check periodically to make sure the film is loading properly by pushing the film against the reel. If you feel the film moving slightly, it is probably being loaded correctly. If the film does not move easily, you are either loading the film too tightly, or the film is not being seated in the grooves. Back the film up until movement takes place. Then continue loading.

Film Loading with Metal Reels
The key to loading a metal reel is to note that the film must load in the direction of the spiral from the inside toward the open end. If the reel is held in the left hand, the film would point toward the open end of the reel, shown at top.

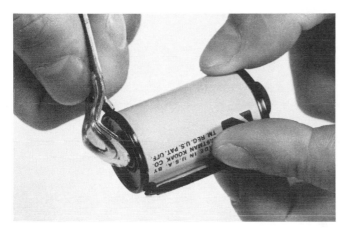

Opening the Film Cassette
In total darkness, the flat end of the film cassette is pried off with a bottle cap opener.

Cutting the Film Tab
Using scissors, cut the tab end of the film. This is done so that the film will have a straight edge to insert into the film reel.

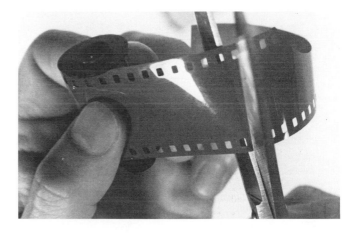

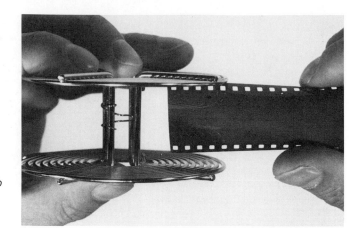

Inserting the Film
Curl the film slightly between the thumb and forefinger of the right hand. Feed the film into the center of the reel and insert it into the clip.

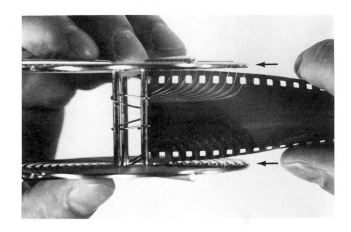

Adjusting the Film in the Reel
Before turning the film into the spiral grooves, it is essential that the thumb and forefinger of the hand holding the film actually touch the edges of the reel.

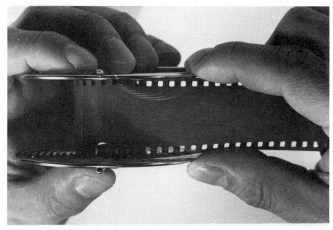

Turning the Film into the Grooves
Keeping thumb and forefinger against the edges of the reel and maintaining a slight curl or curve outward on the film, gently rotate the reel so that the film slips between the grooves.

Removing the Film from the Film Spool
Periodically check to see if the film is loading properly by pushing the film. The film should move easily in the grooves. When the end of the film, which is taped to the film spool, is reached, either peel the tape or use scissors. Now tuck the last bit of film into a groove.

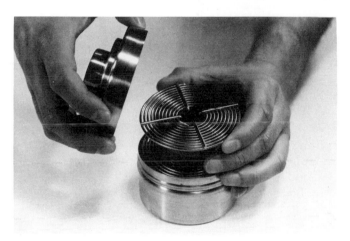

Inserting the Film into the Tank
The film reel is then placed in the developing tank and covered by the lid and cap. Room lights may now be turned on.

When film loading is complete, either cut the spool away from the film, or peel back the adhesive tape that holds the film to the spool. Insert the reel into the developing tank, place the lid on top and turn on the room lights.

We recommend highly that film loading be practiced with dummy film and in room light until you are comfortable with the procedure.

Developing the Film

If a steel tank is used, lift the small cap and tip the tank to keep trapped air from blocking the flow of the developer. Now pour in the developer. Return the cap to the lid and start the timer. Gently tap the tank against the counter to loosen trapped air bells and begin agitating the film by turning the tank over and back for the first 15

seconds of development. Be sure to keep a finger over the cap and lid to avoid losing developing solution or having the lid fall off entirely and ruining the film.

After the first 15-second agitation, place the tank on the counter and do not touch it except for further agitation. Metal tanks can absorb body heat rapidly. This in turn will raise the temperature of the chemicals and cause overdevelopment.

Agitation is done for 5 seconds every 30 seconds. Agitation is necessary to allow fresh developer to reach the film's surface.

About 15 seconds before the timer stops, begin pouring out the developer. Remember to keep a finger on the lid. Now pour in the water bath and agitate the film for about 30 seconds. Pour out the water.

Pour fixer into the tank. Agitate briefly to remove trapped air bubbles from the surface of the film. A rule of thumb for fixing film is to leave the film in the fixer for twice as long as it takes to clear. Film that has been properly fixed will have a clear appearance between the frames and around the sprocket holes or film edges. The film emulsion should *not* have any milky appearance.

Fixing times are different for liquid fixers and powdered fixers. For liquid fixers, the time is 2 to 4 minutes. With powdered fixers, dissolved in water, film fixes in 5 to 10 minutes.

When fixing is completed, pour the fixer back into the container. Used fixer is good for several rolls of film.

Next, remove the lid from the tank and rinse the film in 68° F running water for about 15 seconds. This removes excess surface fixer. Now pour the clearing solution into the open tank. Set the timer for two minutes. Clearing times vary. Check the manufactur-

Preparing the Chemicals
Chemicals that must be prepared from powdered formulas are usually mixed in advance in order for solutions to reach working temperatures. Stock solution of developer is diluted with water to make a working solution at 68°F. Water or stop bath and fixer are also prepared at this time.

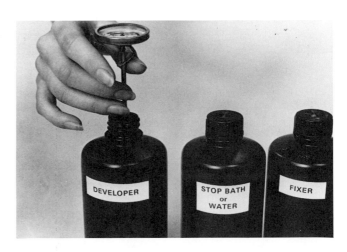

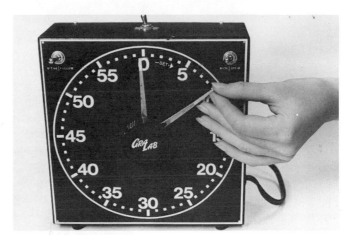

Setting the Timer
Following the manufacturer's recom-
mended time for film developer, set the
timer for an additional 15 seconds
beyond the recommendation. These
extra seconds are for the time it takes
for the developer to fill the tank.

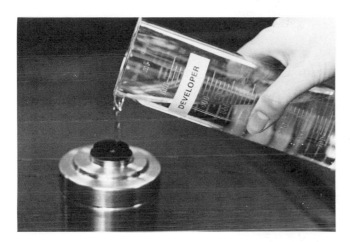

Pouring in the Developer
First, remove the pouring cap from the
lid. Now turn on the timer and begin
pouring in the developer. Once the
tank is filled, replace the cap.

Agitating the Film
The proper agitation technique is to
turn the tank over and back for about
6 times in the first 15 seconds. Keep
a finger on top of the cap to avoid
spilling the developer or losing the lid
entirely and exposing the film. At the
start of the second minute and for each
30 seconds thereafter, agitate the film
for 5 seconds.

Pouring in the Water or Stop Bath

About 15 seconds before the developing time has ended, remove the pouring cap and pour the developer down the drain. Then pour in water or stop bath and agitate the film for about 30 seconds. This procedure halts the developing action.

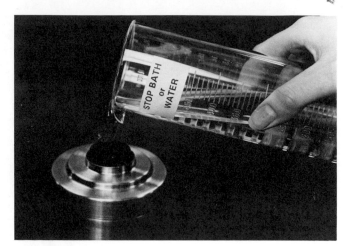

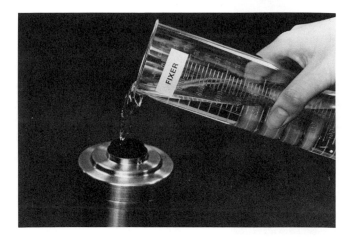

Pouring the Fixer

After draining the water or stop bath, pour in the fixer and replace the cap. Then agitate the film strongly for a few seconds. This allows any air bubbles to escape that might be trapped against the film emulsion. Set the timer for 5 minutes to ensure that all unexposed silver halides are removed from the emulsion.

Pouring in the Clearing Solution

Since fixer is reusable, it should be poured into a storage bottle and marked. The lid may now be removed and the film washed briefly in 68°F running water. Clearing solution is now poured in and time set for 2 minutes. Only minor agitation is necessary.

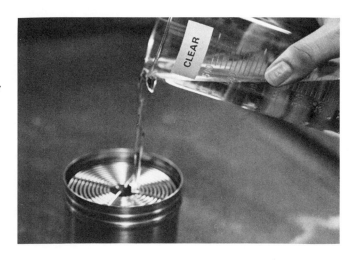

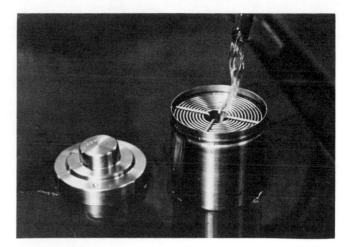

Washing the Film

The clearing agent may be used again, but should be stored in a separate marked container. The film is now washed in running water at 68°F for 5 minutes.

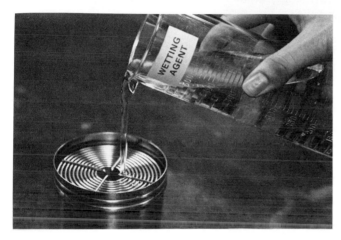

Wetting Agent

After the film is washed, pour in a weak solution of wetting agent. About a drop of wetting agent to a tank of water will suffice. Keep the film in the wetting agent for 15 seconds. Do not agitate since the wetting agent can produce unnecessary air bubbles that will make the squeegee effort difficult.

Squeegee the Film

Carefully unwind the film from the reel. Squeegee the film using a clean rubber squeegee or photo sponge soaked in wetting agent. Now squeegee dry. Hang the film in a dust-free place. Use two film clips, one to hang the film and the other to serve as a weight at the bottom. This keeps the film from curling as it dries.

Storing the Film
When the film is dry, cut it into strips of four or five frames and place these in negative storage sleeves. The negatives are now ready for evaluation and printing.

er's recommendation. The clearing agent may also be saved, but do not pour it back into the stock solution. Use a separate container and mark it as a working solution.

The final film wash should be for at least 5 minutes, although longer washing time will not hurt the film. Maintain the 68° F temperature. Film may be washed in a pressure washer or running water may fall directly into the center of the tank.

TABLE 5-3 Evaluating and Correcting Problems with Negatives

NEGATIVE CONDITION	CAUSE	RECOMMENDATION
1. Milky appearance	Fixer worn out or fixing time too short	Use fresh fixer and refix film until milkiness disappears.
2. Gray, opaque areas on film	Film stuck together during development	Load film reel more carefully.
3. Film completely clear but frame numbers and edge printing visible	Film not exposed. Incorrect loading of film in the camera.	Make sure film engages sprockets in 35mm film.
4. Dark, crescent-shaped marks on negatives	Film was bent during film loading	Practice loading film.
5. Streaks or uneven development	Insufficient or improper agitation.	Pour developer in tank quickly and agitate regularly.
6. Faint shadow detail. Thin highlights, little or no shadow detail.	Film was underexposed and underdeveloped.	Check film speed and light meter. Follow proper developing times and dilutions.
7. Dense shadow detail but highlights are thin.	Film was overexposed and underdeveloped.	Check film speed and light meter. Check condition, dilution developer.
8. Faint shadow detail and dense highlights.	Film was underexposed and overdeveloped.	Check film speed and light meter. Check developer and temperature.
9. Adequate shadow detail but dense highlights	Film normally exposed but overdeveloped	Follow recommended time, check temperature.

After washing, immerse the film into the wetting agent for about 30 seconds. Do not agitate the film as this causes excess air bubbles to form. Remove the film and squeegee to remove excess moisture. Wetting agent may also be saved and reused.

Hang the film to dry in a dust-free place. Use film clips or clothespins to weight the film to minimize film curl as the film dries.

After the film is completely dry, cut the negatives into strips of five exposures and insert these into glassine or clear plastic negative sleeves. You are now ready to begin the printing process.

6

printing

Making enlargements from negatives can be a most exciting part of the photographic process. It is an outgrowth of steps already learned. The way film is exposed in a camera has many similarities to the way photographic paper is exposed with an enlarger. In addition, film developing and print processing are also similar. The first step in learning to print is to become familiar with the equipment.

The Enlarger

Enlargers, sometimes called projection printers, are used to make big pictures from smaller negatives. Enlargers are grouped according to negative size. Small format enlargers accept negatives from 8mm to $2\frac{1}{4} \times 3\frac{1}{4}$ in. Professional enlargers accept negatives up to 4×5 in. Some commercial enlargers are made for negatives 5×7 in. and larger.

Enlargers are also grouped according to their projection or lighting systems. One type is called a condenser enlarger. Another is known as a diffusion enlarger.

condenser enlarger

A condenser enlarger projects an incandescent light source through a set of glass elements or condensers. These condensers focus and sharpen the light which is then passed through a negative and lens

to form an image on the baseboard or easel. Prints made from a condenser enlarger are usually quite sharp and contrasty in appearance.

Older condenser enlargers and some less expensive newer models contain a set of condensers designed for a single negative size. If negatives of different sizes are used, the condenser unit must be physically removed and another condenser set substituted. This is necessary in order to project a circle of light large enough to cover the diagonal of the negative used.

Newer and more expensive enlargers use a variable condenser system. More than one negative size can be projected without cutting off the corners of the image. This is done by changing the distance between the condenser elements.

diffusion enlarger

This enlarger operates without condensers. By using a design of a dome-shaped lamphouse and a piece of diffusing glass or plastic, a soft and even incandescent light source is projected through the

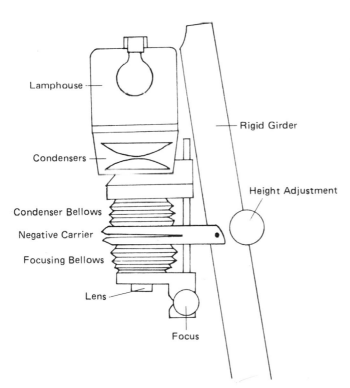

Figure 6-1 Enlarger Parts
Standard condenser enlarger components include a lamp house, condensers to focus the light, adjustable focusing bellows, negative carrier slot, lens focusing adjustment, and height adjustment. Diffuser enlargers are similar except that diffusing glass or plastic replaces the condensers.

Lamphouse

Condensers

Condenser Bellows

Negative Carrier

Focusing Bellows

Lens

Focus

Rigid Girder

Height Adjustment

negative. This may result in reduced contrast and loss of sharpness compared to a condenser enlarger. A diffusion enlarger produces a wide range of tones while hiding imperfections such as dust or scratches. It is ideal for portraits and landscapes, or when a need to reduce image contrast is apparent.

A variation of the diffusion enlarger is the cold light enlarger. Instead of an incandescent light source, a neon-type cold light is substituted. Many photographers prefer the cold light source because it produces better tones, especially in contrasty lighting situations.

The Enlarging Lens

Enlarging lenses are different from camera lenses. A camera lens is designed to deal with a three-dimensional field. An enlarging lens is designed to project a flat field image that the negative represents.

Enlarging lenses are available in a variety of focal lengths. The important principle is that the focal length must match the diagonal

TABLE 6-1 Negative Size and Lens/Condenser Combinations

NEGATIVE SIZE	LENS REQUIRED	CONDENSER REQUIRED
35mm	50mm	2-inch
2¼ × 2¼ in.	75–105mm	3-inch
2¼ × 3¼ in.	105–125mm	3–4-inch
4 × 5 in.	150–165mm	5-inch

TABLE 6-2 Correcting Enlarger Printing Problems

PROBLEM	SOLUTION
1. Image vignettes on print	Match negative size to condenser, lens.
2. Negative "pops" out of focus	Keep enlarger turned on after focusing. Use a red safety filter while inserting paper in easel. Set the time. Turn off enlarger only long enough to remove red filter. Make the exposure.
3. Image prints out of focus	Focus with printing filter in place. Use a magnifier to focus carefully.
4. Only part of print is in focus	The negative plane, lens plane, and easel must all be parallel. If the lens plane is tilted, adjust the knob on enlargers having this feature. Check the negative carrier to see if it is inserted properly.

of the negative. If a mismatch occurs, the lens will not project a circle of light sufficient to cover the diagonal of the negative. The result is reduced light at the picture edges—a corner-cutting or vignetting effect.

the negative carrier

Each negative size also requires a separate, preferably glassless, negative carrier. While glass-type negative carriers provide the flattest image and sharpest focus, the dust problem is severe due to static electricity. Sometimes *Newton's Rings*, a concentric circle of lines, show up when a negative is pressed unevenly against glass.

printing accessories

Several smaller pieces of equipment are necessary to complete preparation for printing. These include an easel to hold the paper, a contact printing frame or sheet of glass, a focusing magnifier, timer, negative cleaning brush or can of compressed air, and a red safety filter. In addition, some minor construction is needed to make tools for adding or subtracting light (burning in or dodging) during the exposure process.

Enlarger Accessories
A basic black-and-white printing setup includes easel, glass sheet for making contact prints, negative brush or canned air, negative magnifier, timer, red filter, variable contrast filters, printing paper, dodging and burning-in tools, and a negative carrier.

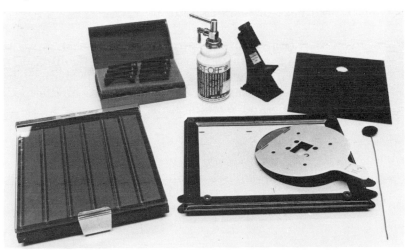

Multiple Contrast Filters
Eastman Kodak's multiple contrast filter printing system produces seven contrast variations within a grading system from 1 to 4. Contrast is increased as the color of the filter darkens.

Printing Papers

Printing papers are supplied in several sizes, surfaces, and contrasts. Most photography shops have sample books. Ask to look at these to gain a firsthand impression of the look and the feel of the paper.

The most commonly available printing papers are those manufactured by Eastman Kodak, Ilford, and Agfa. Others, such as Arista and Oriental Seagull, are usually available by mail order.

The standard sizes of printing paper are universally accepted as 5 × 7 in., 8 × 10 in., 11 × 14 in., or 16 × 20 in. Packages are supplied in quantities of ten sheets in the larger sizes and 25 sheets for the smaller sizes. Boxes are supplied in 50- and 100-sheet quantities. Significant savings are possible if paper is purchased by the box rather than by the package.

fiber base or resin-coated

Traditional printing papers are made from fine quality fiber in a variety of weights, surfaces, tones, and contrasts. In recent years, resin-coated paper has become widely available. The emulsion and paper backing are encased in a resin-coated support that reduces processing and washing time.

paper grading

Papers are supplied as either graded or multiple contrast. In graded papers, contrasts range from grades 1 to 5. The lower numbers produce less contrasty images than do the higher numbers. Grades

1 and 2 are called soft or low contrast. Grade 3 is slightly contrasty, while grades 4 and 5 are called hard or contrasty.

When papers are designated as multiple contrast or polycontrast, it is possible to achieve more than one contrast grade on a single sheet of paper. Multiple contrast paper actually contains two printing emulsions that are sensitive to two different colors of light—yellow and magenta. By using a set of printing filters, either singly or in sequence, it is possible to alter the total contrast or to change contrast in various areas of the image. Printing filters are supplied in sets with contrast in the range of grades 1 to 4.

Prints made from multiple contrast filters often are not as rich in appearance as those made on graded paper, since not all of the silver in a multiple contrast emulsion is exposed.

weights, surfaces, and tones

Fiber base enlarging paper is available in both single weight and double weight. While single weight is the least expensive, it is more difficult to handle in processing and drying. Double weight has a better look and feel as a finished print. Resin-coated papers are available only in medium weight.

Surfaces of papers refer to both texture and finish. A glossy paper is both smooth and highly reflective. A matte paper may have a texture as well as a nonreflective surface. Paper surfaces are designated as glossy, semimatte, or lustre and matte. In Kodak's system, a glossy paper is called an F surface, while semimatte is an E surface, and matte is an N surface.

Printing papers are also identified by their emulsion color or tone. Paper tones are either warm black or cold black. Most images are made on cold black papers, although some landscapes or portraits are enhanced when printed on warm-tone paper.

paper speed

Generally, the lower the contrast of the paper, the more sensitive is the emulsion to light. In the lower paper grades, there is about a one f/stop difference in emulsion speed. For example, a grade 1 paper calls for about half the exposure time for that of a grade 2 paper. The higher number paper grades are usually a little closer in emulsion speeds. For example, some manufacturers list the same emulsion speed for grades 4 and 5.

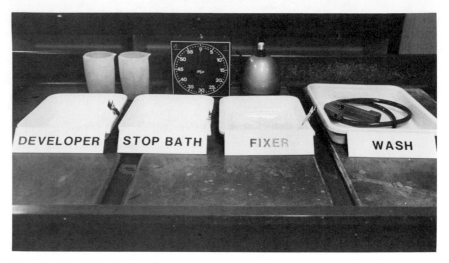

Chemicals for Print Processing
Prints are processed under amber safelight. The print is immersed and agitated gently in the developer. Developing action is halted in a stop bath and the print is transferred to a fixing bath. Sometimes a clearing bath is used before the final wash.

Equipment for Print Processing

The following equipment and accessories are necessary for black-and-white printing:

> Sink and Thermometer
> Processing trays 8 × 10″ or larger
> Quart-size measuring beakers
> Printing tongs
> Sweep second timer or clock
> Yellow-amber safelights
> Tray siphon for print washing

Chemicals for Print Processing

The basic chemicals for print processing are similar to those of film processing. A developer, short stop, fixer, and sometimes a clearing agent are used.

In general, prints are first immersed in a paper developer, such as Kodak's Dektol. After a specified period, developing action is halted in an acetic acid short stop. The print is then placed in fixer to remove unexposed silver halides. Following a brief wash, the print

may be placed in clearing agent to neutralize the fixer remaining in the print. The print is then washed and dried.

The procedure for processing fiber base paper varies a little from that of resin coated paper.

fiber base print processing

The paper is immersed evenly in the developing solution prepared from stock. For example, Kodak's Dektol is mixed as a full strength stock solution and is then diluted with water to make a working solution. Normally the stock solution is diluted 1:2. One part Dektol is diluted with two parts water at 68°F. The print is gently and continuously agitated for 2 minutes or more.

After development, the print is drained and immersed in a working solution of 28 percent acetic acid for 30 seconds. The print is once again drained and then immersed in fixer diluted according to the manufacturer's recommendation. The print, with occasional agitation, remains in the fixer for 5 to 10 minutes. After a short wash to remove surface fixer, the print is placed in a solution of clearing agent. The print is cleared for 2 to 5 minutes and is then washed in a siphon tray or drum washer at 68°F for 10 minutes. To dry, the print may be placed in a flattening solution, or after excess moisture is removed, transferred directly to a heated flat bed or drum dryer.

resin-coated print processing

This printing paper contains an emulsion and paper base that is entirely enclosed in a resin coating. Overfixing and overwashing make it susceptible to chemical or water infiltration that can damage the white values of the print. Therefore, shorter and more accurate processing and washing times are necessary.

The print is developed for 1 minute. It is then drained and transferred to the short stop for 5 seconds and fixed from 1 to 2 minutes. Washing time should be held to a maximum of 4 minutes. No clearing agent is necessary.

The Printing Process

In any darkroom there is a wet side and a dry side. At the enlarging station, there should not be any moisture, either on the hands or in the form of a damp towel lying on the working space. Contami-

TABLE 6-3 Print Processing Procedure

FIBER BASE PAPER

1. Immerse in developer, tap down corners until print is soaked. Agitate gently, remove, and drain. Develop for 2 minutes.
2. Transfer to stop bath. Agitate, drain, and remove. 30 seconds.
3. Immerse in fixer, agitate occasionally. Fixing time 5 minutes.
4. Wash briefly and then immerse in clearing agent for 5 minutes.
5. Wash thoroughly in running water for 10 minutes.
6. Immerse in print flattening solution for 15 seconds.
7. Squeegee and place in heated drum or flat bed dryer.

RESIN-COATED PAPER

Immerse in developer, agitate gently, remove, and drain. Develop for 1 minute.

Transfer to stop bath. Agitate, drain, and remove after 5 seconds.

Immerse in fixer, agitate occasionally. Fixing time 2 minutes.

Wash for 4 minutes.

Squeegee moisture and dry on mesh drying racks.

nation of negatives and printing paper can result in ruined prints. This is most obvious as chemical staining or the appearance of fingerprints as the print dries.

Prior to making an enlargement, familiarity with the enlarger and processing is gained by making photograms and contact sheets.

making a photogram

Photograms are cameraless pictures whose origins are traced to the earliest days of photography. A pleasing design can be made from almost any object laid directly on the printing paper. The enlarger light is turned on for a short period. Wherever light is prevented from striking the paper, the result is an outline white image surrounded by blackened silver when the print is processed. Interesting photograms can be made with objects that are translucent rather than opaque. This results in gray tones being added to the black-and-white image.

The first step is to place an empty negative carrier in the enlarger. Now turn on the enlarger and open up the lens. Raise the enlarger until the light projected covers an easel placed on the baseboard. Now focus the light by sharpening the edges of shadow line provided by the negative carrier. Next, stop or close down the lens two f/stops to reduce the intensity of light that can strike the paper. If graded paper is used, use grade 3 or 4. If multiple contrast paper is used, use a number 3 filter. Turn off the enlarger and set the timer for about 6 seconds. On most medium-size enlargers, 6 sec-

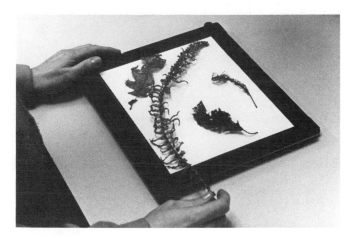

Photogram Preparation
A photogram is made by placing opaque and semi-opaque objects on a piece of printing paper and exposing the paper to white light. The exposure can be made by means of an enlarger, a bare bulb, or sunlight.

A Photogram
The finished photogram reveals the outline of the object placed on the paper. Objects that are semi-opaque result in middle gray tones.

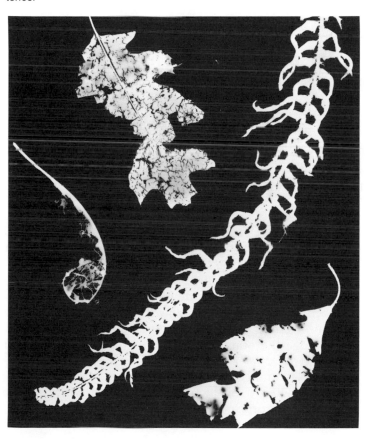

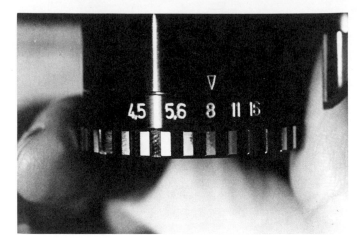

Stopping Down Lens
Light is focused sharply with the lens wide open. Exposures are made with the lens stopped down two f/stops. This provides better exposure control and a sharper print.

Timer
The timer is set for the correct first exposure. For a contact sheet, set the time for 6 seconds. For printing, the time is 10 seconds.

onds provides ample exposure time with the conditions described. If, after processing, the dark tones are too light, increase the exposure time.

Next, insert a piece of printing paper emulsion-side-up into the easel. The emulsion side has a slight sheen. If the sheen cannot be seen under the safelight, lay the paper on the counter and see which way it curls. If the edges curl up, that is the emulsion side. Now arrange the objects selected on top of the paper and make an exposure.

The image that appears in the developer will be a negative image, having a black background and white or gray tone objects. Follow the processing procedure as shown in Table 6-3.

After the print has been in the fixer for several seconds, it may be viewed under white light. Check first to be sure that opened printing paper is repackaged before turning on room lights.

making a contact sheet

A contact sheet is a picture of the negatives from a roll of film. The name contact comes from the placement of the negatives directly against the printing paper. The enlarger light is used to make the exposure.

A contact sheet has a number of uses. First, it serves as a visual, positive reference sheet for the negatives. Second, individual contact images may be edited or cropped with a grease pencil to select negatives and to determine how they should be printed. Third, the contact sheet serves as a handy filing system. The sheet can be punched and placed in a notebook. It is given a number corresponding to one placed on the negative sleeve. Negatives are then easily found for printing at a later time.

Exposing and processing a contact sheet is similar to that done with a photogram. The difference is that the negative must be placed firmly in contact with the printing paper. Therefore, a paper easel cannot be used. Instead, a printing frame or a sheet of glass, preferably a little larger than the 8 × 10 in. printing paper, is used.

Negatives in a Contact Frame
Contact sheets can be made by using frames designed for the purpose or a sheet of glass placed in contact with the negatives and printing paper. The emulsion side of the negatives must face the printing paper if images are to be seen corrected left to right.

The enlarger is first raised high enough to project light onto an 8 × 10 in. printing area. Before turning the enlarger off, locate where the paper will be placed. This can be done in two ways: leave the enlarger on and place a red safety filter in front of the lens, or use masking tape to mark the paper position.

The lens is stopped down two f/stops and the timer is set for about 6 seconds. If a multiple contrast filter is used, insert a number 3 filter into the filter holder. With the enlarger turned off, or left on with a red safety filter in place, position the paper on the baseboard and lay the negatives on the paper. Negatives are printed with the film emulsion facing the paper emulsion. This keeps the images from being printed backwards.

It is easier to make a contact sheet when the negatives have been stored in a clear plastic storage sheet. If negatives are stored in other than clear plastic sleeves, each negative strip will have to be placed on the printing paper separately. Always hold negatives by the film edges to minimize scratches or fingerprints.

A glass sheet is now placed on top of the negative and paper to bring the negatives into firm contact with the paper. An exposure is made and the sheet is processed.

evaluating a contact sheet

It is helpful to have a small power magnifier to view the small contact pictures. Only under close inspection can the composition, sharpness, and potential tonal qualities be revealed.

Viewing the Contact Sheet
The contact sheet provides information about the negatives and serves as a convenient file record. It is best to view the individual images with a magnifier.

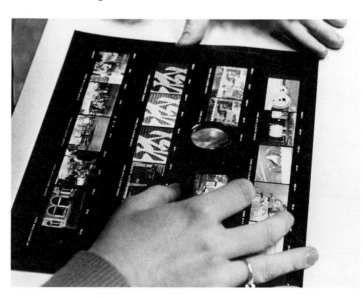

One of the reasons for using a number 3 filter when exposing a contact sheet is to give a visual awareness of which negatives are likely to print normally when enlargements are made. Contact images that appear too dark or too light will require printing adjustments if the contact print is exposed correctly.

Comparing contact sheet images to the negatives viewed at a light box helps to develop an understanding of negative density and contrast and their relationship to printing.

printing from negatives

After picture choices have been made from the contact sheet, the enlarging process begins. Several factors go into the decision about what kind of print is desired and what is possible from the negative.

Three Different Negatives
Negatives may be analyzed both in terms of density and contrast. A normal negative, at left, has moderate density and good contrast. An overexposed negative, right, often has blocked or dense highlights and full shadow detail. An underexposed negative (see next page) shows little difference between highlights and shadows, or low contrast.

Underexposed Negative

This is entirely subjective, but most photographers attempt to make prints that contain rich black tone, subtle middle tones, and sparkling highlights. Any forcing of an image beyond the conditions of the negative may result in prints having muddy black tones, compressed middle tones, and grayed-over highlights.

Every printing decision involves a look at the quality of the negative. Determine first if the negative is in the normal range. Does it have clarity, crispness, and brilliance? Are the highlights thin enough to print through easily? Is there some shadow detail? Images that appear normal on the contact sheet are probably in the normal range.

If the negative is not in the normal range, is it too dense or too contrasty? Or is it too thin or lacking in contrast? Contrast represents a difference between highlights and shadows. If there is little difference between highlights and shadows, the negative is low in contrast. If there is a lot of difference, the negative is high in contrast.

Matching Negative and Paper Contrast Paper contrast is used to correct contrast deficiencies in the negative. Paper contrast is also used to change the mood of the original scene.

To correct for negative contrast deficiencies, review the contrast

TABLE 6-4 Matching Negative Contrast and Density to Paper Contrast*

TYPE OF NEGATIVE	RECOMMENDED GRADED PAPER	RECOMMENDED MULTIPLE CONTRAST FILTER
Contrasty, with blocked highlights, requiring a long exposure time.	Grades 1,2 Kodak Kodabromide Ilford Ilfobrom	Filter #1, #1½ Kodak Polycontrast Ilford Multigrade
Normal negative with brilliance. Highlights are slightly dense with some shadow detail.	Grades 2,3,4 Kodak Kodabromide Agfa Brovira Ilford Ilfobrom Ilford Galerie Oriental Seagull	Filter #2½, #3 Kodak Polycontrast Ilford Multigrade
Thin negative with soft highlights and almost no shadow detail.	Grade 5 Kodak Kodabromide Agfa Brovira	Filter #3½, #4 Kodak Polycontrast Ilford Multigrade

** Check manufacturer's recommendation, since emulsions vary from brand to brand.*

of the negative. The greater the negative contrast, the lower contrast the paper should be. Conversely, the lower the negative contrast, the higher paper contrast needed to bring print contrast to a normal level.

To change the mood of a scene, either high or low contrast paper or filters may be used. However, practice in judging printing exposure and the use of special printing techniques may be necessary (see printing suggestions, pp. 101–102).

Making a Test Print Once a negative and paper contrast decision has been made, it is time to make a test print.

The first step is to insert the negative into the negative carrier with the emulsion side facing down toward the easel. Make sure the

Inserting Negative into Carrier
The negative selected for printing should be placed in the negative carrier. Remove lint or dust by means of a negative brush or canned air.

negative is as dust-free as possible. Surface dust can be removed with compressed air. In some cases, dust can be picked off with a small spotting brush, or the negative can be brushed carefully with a fine camel's-hair brush. If dirt or dust cannot be removed with air or brush, then apply film cleaner and use a lintless wipe.

The enlarger is then raised to a height necessary for the desired print size. The lens is opened for easy focusing. Compose the image by moving the easel and adjusting image size. Use a focusing magnifier to achieve the greatest focus. Now stop down the lens two f/stops. Review the contrast and density of the negative and select a paper or filter contrast. In many cases, a number 3 contrast will be appropriate.

There are at least three approaches to making a test print. These include a test using a piece of cardboard to produce various exposure densities, printing through a projection print scale, and a basic first exposure test.

1. TEST PRINT USING CARDBOARD After the paper contrast has been determined, a piece of printing paper, or a portion of a full sheet, is placed in the easel. The lens is stopped down two f/stops and a first exposure of 2 to 3 seconds is made. Now, using the cardboard, cover

Checking Focus with Magnifier
After raising the enlarger for the appropriate composition on the easel, focus the image with the lens wide open. An image magnifier simplifies the focusing procedure.

Test Print with Cardboard
When making a test print, set the time for 5 seconds and the lens closed down two f/stops. Make 5-second exposures by moving the cardboard. A full test print provides more visual information than does the test strip.

about a fifth of the paper area and reexpose the paper another 2 to 3 seconds. Repeat this process until there are four or five segments whose exposure ranges from about 4 to 20 seconds.

The print is now developed for the recommended time. Inspection should be made under white light until experience is gained at judging print quality under safelights. You should be aware that wet prints inspected under white light will look different when dry. If time permits, dry down will give a more accurate sense of the final result.

Advantage: This method almost always produces at least one segment that is close to the desired exposure. However, if all of the segments are too light, double the times and make a second test print. If all of the segments are too dark, cut the time in half.

Disadvantage: The various exposure segments produce definite lines of density that interfere with a good overall look at the composition and tonal values of the print. In addition, areas of the print that need extra light because of excess negative density may not be easily determined.

2. Test Print Using Projection Print Scale Eastman Kodak makes a special projection print scale. This is a pie-shaped film

93

20 15 10 5

SECONDS

Test Print Results
Under white light, evalute the test print. Does it have the proper contrast? Is it too light or too dark? Is it properly composed?

Projection Print Scale
A projection print scale placed over the print produces a series of exposure wedges with the time in seconds printed on the image. Select the best time and make an exposure without the density negative.

positive containing various numbered densities. The film scale is laid directly on the printing paper and a 1-minute exposure is made with the lens stopped down two stops.

After processing, the segment most closely approaching correct print values is selected. That segment has a number printed on it to indicate the amount of exposure time in seconds. A new print is then made without the scale.

Advantage: This is a simple, almost foolproof method to arrive at the base exposure. It works well with most dense negatives due to the long exposure time required in order to use the scale.

Disadvantage: The print scale is only 5 × 7 in. When printing in larger sizes, the edges and corners of a larger print cannot be evaluated properly. In addition, dense highlight areas that need more exposure or reduction of time for shadow exposure are not easily determined.

3. BASIC FIRST EXPOSURE TEST This method requires some practice and experience. But it does provide a means of evaluating the entire print without the distractions of exposure segments or wedges.

As in the first two methods, a contrast paper grade or filter decision must be made prior to printing. The lens is then stopped down two stops and a sheet of paper is inserted into the easel. From our lab experience, we find that many medium-sized enlargers produce an acceptable 8 × 10 in. print from a normal negative and a grade 3 contrast in about 10 seconds. If a 5 × 7 in. print size is desired, the basic exposure time is reduced to 5 seconds.

The print is evaluated to determine whether contrast is correct and if the print values are too light or too dark. If the print is too light, the time is doubled. If the print is too dark, the time is halved.

Advantage: The photographer who is experienced in evaluating negative contrast and density can make an initial test print quickly. The entire print can be seen for its effect under a single exposure time. Areas needing more exposure or reduced exposure can be determined. The composition and cropping or editing of the print can also be determined without distraction.

Disadvantage: For the beginner, this method is wasteful both in paper and in time. Until the qualities of negatives and printing papers are learned, it is better to develop experience through other test print methods.

Special Printing Controls

In many bright light exposure situations, light does not fall evenly on all parts of the scene as it might on an overcast day. In bright sunlight, some areas of the image will reflect more light than others. The negative shows this added reflectance as an increase in density. Other areas, such as shadow, may have little or no density on the negative. Both the highlights and shadows may not average out when a decision to use a particular paper grade is made. An average exposure may still produce prints with areas that receive too much light or too little light.

If a test print appears to have normal contrast, but contains bright areas that show insufficient detail, these areas will need more light than received in the original exposure. This selective addition of light is called *burning in*.

Conversely, if a normal-looking print contains areas of shadow or lower-level middle tones that are too dark, then some light must be subtracted from the original exposure. This is known as *dodging*.

burning-in procedure

How much additional light an area of a print needs is highly subjective. Generally, burning in calls for considerably greater exposure time than the base exposure. For example, if the base exposure of 10 seconds produced a print with good contrast but weak highlights, a burning-in time of 20 to 30 seconds or more might be necessary to bring up the highlight detail in the next print.

Burning in is done using a piece of cardboard at least as large as the print size. A hole about the size of a nickel or a dime is cut. After the basic exposure is made, the cardboard is held in position under the lens at a distance of 3 to 5 inches from the print. A burning-in exposure time is calculated and the enlarger is turned on. The cardboard is kept moving at all times in a circular motion in order to blend the area to be burned in. If the cardboard is held still, an outline of the cutout will show on the print.

dodging procedure

Dodging is the subtraction of light from the main exposure. Thin or light areas of the negative must be restricted so that the print is not too dark. A simple dodging tool can be made from a piece of thin wire and a cardboard circle or wedge that is taped to it.

Burning In

Burning in is giving extra exposure to the light areas of the image in order to enhance highlight detail. A good burning-in tool is a piece of cardboard with a small hole cut in the center. The board is kept moving during the burn-in exposure.

Burning-in Results

Compare the prints below. At left, the facial highlights were burned in; at right, using normal exposure and no burn-in, the highlights are washed out.

Dodging Procedure

Sometimes shadow areas need to be exposed less than normal in order to see detail. A dodging tool made of a thin wire and a piece of stiff black paper or cardboard can be used to block the light during the base exposure. Keep the dodging tool moving while the exposure is made.

Results of Dodging

Compare the prints below. At left, dodging was done in the shadows; at right, the shadows were not dodged and significant detail is lost.

The dodging tool must be kept in motion at all times to avoid casting a shadow on the print. Dodging times are usually short, perhaps 2 to 3 seconds.

Evaluating the Print

Inspection of the print after fixing and a short wash should be made under white light. Always be sure that printing paper is repackaged before turning on any room lights.

Evaluation should include the following:

1. Image contrast: has the right printing filter or paper grade been chosen to produce the effect desired?
2. Is there a crisp white value and a rich black tone? Are the middle tones clearly separated, or is the result muddy in appearance?
3. Do the highlights contain sufficient detail? If not, burning in must be done on the final print.

Contrast Comparisons
Different contrast effects can be obtained by using different paper contrasts, or through the use of variable contrast filters. The following three images were printed with different filters on multiple contrast paper. Below, a #1 low contrast filter was used.

In the print above, a #3 filter produced a more normal result.
Below, a #4 filter compressed the gray scale to give more
contrast.

4. Are the shadow areas sufficiently detailed or are they too black? Must they be dodged in the final print?
5. Is the print properly focused and is the composition pleasing, especially at the edges and the corners?

Some Printing Suggestions

1. *Handling the print in solution* Try immersing the print into the developer from the back of the tray toward you in one smooth motion. Once the print is wet, use print tongs to push down the corners so the print develops evenly.

2. *Development rate* A print with sufficient exposure usually shows the beginning of image development in 5 to 10 seconds for resin-coated paper and 15 to 20 seconds for fiber base.

A print developing faster than its normal image appearing time will be too dark after full development. A print showing little detail after its normal development rate will be underexposed.

3. *Print appearance under safelights* When a print is fully developed, it will look darker than normal under yellow-amber safelight, compared to white light. If the print looks just right under safelight, chances are it will be too light when viewed under white light.

4. *Adding contrast* Most multiple contrast printing papers can be given a boost in contrast by using more than one printing filter in the exposure process. Use the darkest or highest number filter first. Make a 4-second exposure for an 8 × 10 in. print. Then replace the dark filter with one intended for an overall exposure and make a normal exposure. The darker or more contrasty filter greatly affects shadows, leaving middle tones and highlights only slightly affected. The result is a print with rich black tones.

5. *Flashing to reduce contrast* Occasionally a scene that suffers from strong backlight does not respond well to the burning-in procedure. In that case, the print may be flashed with weak white light to bring up the background. Since this process reduces overall contrast, higher numbered filters or paper grades should be used. After making a normal exposure, stop down the lens completely, remove the negative and carrier and raise the enlarger to its maximum height. Expose the print to this weak light for one or two seconds. If the print shows too much graying, reduce the flash time.

6. *Softening the image appearance* Some portraits and landscapes do not look as good when printed with a condenser enlarger as they would if printed with a diffusion enlarger. To reduce hardness, the light must be diffused. Methods include using a ground glass or plastic diffuser in the condenser head, placing a nylon stocking over the enlarger lens, or using vaseline smeared evenly on a clean sheet of glass and held under the lens. All of these methods can soften image appearance, but cause a loss of light intensity through the enlarger. An increase in exposure time is necessary. If the image loses too much contrast, use a more contrasty paper or filter.

7. *Changing exposure time after changing image size* After a test print is made, a decision may be made to change image size. The original time for the test print must be changed because the light weakens as the distance from the lamp to the paper increases. If a 5 x 7 in. print size were changed to 8 x 10 in., a doubling of the exposure time would not be unusual.

8. *Removing dust from negatives* Negatives should be stored in sleeves to minimize dust. However, dust in an enlarger that is disturbed by lamp heat can settle on the negative. One remedy is to raise the lamp house with the enlarger turned on. A glance at the negative easily shows the dust. It can be removed by pressurized air or with a spotting brush. Be careful when doing this in a group darkroom unless there is adequate light baffling for each enlarger station.

Another method is to remove the negative carrier, close the enlarger head, and hold the carrier at an angle below the lens with the enlarger turned on. Turn off the enlarger before returning the carrier to position. If scratches are evident, apply a no-scratch solution or use nose oil on the emulsion side.

Drying Methods

The final step in print processing is to dry the print. Methods differ for fiber base and resin-coated papers.

Drying a Fiber-base Paper Prints are taken from the wash and may be immersed in a print flattening or glossing solution for about 30 seconds. If the print has a glossy surface but is to be dried nonglossy,

excess glossing solution should be removed with a squeegee. If the print is to be dried glossy, do not squeegee excess glossing solution. Lay the print on the apron of a drum dryer—face up for glossy and face down for matte. If a flat bed dryer is used and glossy prints are desired, special metal glossing plates must be added.

Fiber-base paper does not dry evenly in the absence of heat and pressure. If no dryer is available, paper is placed in a special corrugated blotter roll and allowed to air dry.

Drying a Resin-coated Paper After taking the prints from the wash, carefully remove excess water using a squeegee. The print is then placed on air drying mesh frames, or allowed to dry on a clean table surface. The drying process can be speeded by using a hair dryer or a heated drying cabinet.

Resin-coated prints should never be placed in direct contact with the heated surface of a drum or flat bed dryer. The contact may cause the resin surface to melt or mottle.

Using a Squeegee
After the wash, excess water is carefully removed with a squeegee.

Drying the Print
Resin-coated prints are dried on mesh screens using heated air or are left to dry at room temperatures. Fiber base prints are dried in drums or flat bed dryers, or rolled in a special blotter roll and air dried.

7

post-printing techniques

When a print has been dried, it is time for final evaluation. Is the contrast chosen appropriate for the subject matter? Are the shadow areas rich in dark tone? Is there brilliance in the highlights?

Answers to these questions may show that some modifications could be made to extend or improve the overall brilliance of the print. A technique called bleaching can be used to brighten the highlights of the print. A technique called weak toning may be used to enrich the darker tones. Further inspection may show that the print surface has tiny specks of dust or scratches that resemble snow. These can be minimized or eliminated through the process of spotting.

Finally, how is the print to be presented? Should it be dry mounted, overmatted, or trimmed flush?

Together, these post-printing techniques extend the range of control, giving the photographer options beyond the darkroom.

Improving Print Brilliance: Bleaching

Beginning photographers are often surprised at the difference in appearance when a print is viewed wet under amber safelight and when it is viewed dry under white light. Under the safelight, prints appear darker and more contrasty. But tones flatten as a print dries.

Highlights that looked white under safelight often turn out disappointingly dull and gray.

To restore brilliance to the highlights, a technique called bleaching or reduction is used.

Equipment and chemicals needed include white printing trays, a bleach solution of potassium ferricyanide, some fixer (preferably without hardener), and a water bath. Also useful are cotton swabs, print squeegee, and a sheet of glass or a flat-bottom tray.

The compound potassium ferricyanide, also available in packaged form as Kodak Farmer's Reducer, reduces or bleaches metallic silver when a print is placed in solution. Since the compound reduces the silver more quickly in the highlights, or areas of least silver concentration, the process is controllable through both time and solution strength. Darker tones normally remain unaffected in the bleaching process.

Bleaching may be used either as general reduction or as local reduction. In both instances, a few grains of potassium ferricyanide are added to water at the rate of about a half teaspoon to a quart. The solution should appear pale yellow in a white tray and be moderate in strength. Do not make the solution too strong or important highlight detail can be lost.

Since potassium ferricyanide oxidizes rapidly, the solution cannot be left standing for periods longer than about 30 minutes. If the solution appears weak or greenish in color, it has probably oxidized and must be thrown out. Under no circumstances should the bleach be stored in a closed bottle. The gaseous nature of potassium ferricyanide in solution could cause a minor explosion if stored under pressure.

general bleaching

When the intent of bleaching is to heighten the overall brilliance of the print, general reduction may be used. This is done in white light. A presoaked print is immersed in a tray of bleach. Allow the print to remain in the bleach for about 15 seconds. The print is then drained, immersed briefly in a tray of water to prevent formation of cyanide gas and transferred to a tray of fresh fixer, preferably without hardener. The effect of the bleaching action may now be inspected. If insufficient bleaching took place, the print is reimmersed in bleach and the process is repeated.

Generally, the most efficient inspection is done when the print is dry. To simulate a dried print condition, immerse the print in

Bleaching Effects
The effect of using bleach to lighten or brighten the white and gray areas of the print is shown below. An identical print, but without the use of bleach, is shown at the bottom.

water following the fixer and squeegee the excess water from the print. It is helpful to have a nonbleached dry print handy for comparison.

To finish the print, follow the washing and drying procedure normally used after a print has been fixed.

local bleaching

Small areas of a print may need to be reduced without risking the effect of the bleach on general highlights. This may be true, for example, in a portrait, where the whites of the eyes can be brightened while leaving skin tones untouched.

Bleaching in this manner can be done with a small plastic ferrule spotting brush, cotton swab, or cotton ball. It can be done in the darkroom at the time of printing or reserved until after the print has dried. Darkroom bleaching has the disadvantage of contaminating the fixer for other prints that may not be bleached.

The print is first presoaked, drained, and placed on the back of a smooth-bottom printing tray. A small amount of solution is now applied locally and the print is immersed in the fixer. Apply local bleach carefully, using a sponge to wipe up any runs caused by the brush or cotton.

One caution: If a metal ferrule spotting brush is used, the ferrule must be kept from contact with the bleach. Use of shellac or a heavy application of rubber cement on the ferrule will prevent formation of a blue stain that can ruin the print.

Local Bleaching
Local bleaching may be achieved with the use of a cotton swab or a small spotting brush. Use a small sponge to soak up bleach runoff to prevent staining of adjacent areas

Improving Print Brilliance: Weak Toning

A weak solution of selenium toner can be used with most printing papers to increase contrast and depth in the darker tones. In addition, selenium toner acts as a preservative, making silver chloride more resistant to oxidation.

Prints should be washed thoroughly prior to any toning. Selenium toner is diluted at a ratio of about 1:15. This dilution works well with resin-coated papers.

A presoaked print is immersed in the solution and agitated continuously for about 1 minute. The print is then transferred to a running water bath, and washed and dried in the usual manner.

Do not leave the print too long in the selenium toner. When the surface selenium solution is diluted in the wash water, print tones darken or shift color beyond what was observed at the time of toning. An untoned comparison print should be placed nearby in order to note the effect of the toning.

The use of bamboo or plastic tongs is advised when handling the print. Selenium is toxic and can be absorbed through the skin.

Spotting the Print

The process of removing dust and scratches from the print surface is called *spotting*. Almost all prints need some spotting. However, careless handling of negatives and unclean darkrooms can only make the dust problem worse.

There are a number of ways that spotting can be done. The variations occur in the choice of spotting medium, size of the brush, spotting wet or nearly dry, and the way in which the brush is held during spotting.

The Spotting Medium There are three types of applications. These include dyes, such as Spotone or Touchrite, that stain the gelatin print emulsion; poster paints, such as Kodak's Spotting Colors; and soft lead pencils.

The dye method is the hardest to apply, but is the preferred method for exhibition prints because the dye blends into the emulsion.

Paints are easy to apply, but leave a matte finish that is obvious when a print is viewed at an angle. Paints are ideal for matte papers, but do not work well on glossy surfaces.

Soft lead pencils work only on matte papers. This method is

Dust and Scratches on Print Surface
Dust and scratches, left, are corrected through careful use of spotting materials. A print that has been spotted is shown at right.

acceptable for only the smallest of dust spots. Pencils leave a shine when the print is viewed at an angle and can become smudgy if the print is handled.

Brush Selection A good red sable brush is absolutely essential. The brush must be able to form a sharp point when moistened. Photographers use brushes that range from a #1 to #0000. This is a personal preference depending on experience and how much dye you prefer to carry on the brush.

In addition to the brush, a white saucer, a small sponge square, and a bottle of spotting medium, such as Spotone #3, will be needed. Spotone #3 matches the tones of most neutral black printing papers.

Spotting Technique A description is no substitute for a demonstration of the spotting process. But with reading, practice, and an instructor's help, spotting can be mastered. Practice should be done first on prints that will be discarded.

Spotting Materials
Spotting materials needed to remove dust and scratches include a good quality sable brush, small sponge, white saucer or palette, water, and spotting liquid. Various shades of gray are obtained by mixing the black spotting liquid with water.

Spotting Technique
More effective results are obtained when the spotting brush is held in a vertical position and using as little pressure as possible.

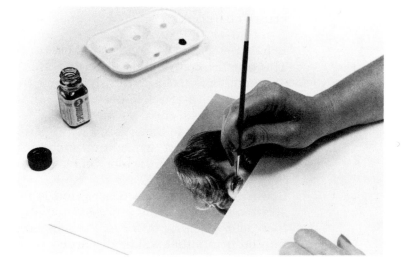

First, place a few drops of water in the center of the saucer. This is the reservoir that will be used to dilute the full strength dye. Next, add a drop or two of dye to the edge of the saucer. By mixing some dye with water it is possible to obtain various shades of gray. If the moistened brush is twirled gently against the saucer, the brush point is maintained. In addition, the wetness of the brush and the dye strength can be determined.

Hold the dye-moistened brush vertically over the area of the print that requires spotting. Lay a clean piece of paper on the print to protect the surface from oil and dirt that may be on the hand holding the brush. Gently cover the dust spot with a light touch of the brush. Do not press the brush too hard or the point will break and spotting will be impossible.

Successful spotting is done best by having enough moisture and dye in the brush. The brush must also be held vertically in order to see the point of the brush in relation to the dust spot. Have enough patience to go over a spot several times if necessary in order to blend the spot into the surrounding tones.

Most photographers work in patterns when spotting. Some start from the center and work their way to the edges of the print. Others work from dark to light areas, taking advantage of the weakening of the dye's intensity as the fluid is used and the brush dries out.

Remember that the dye stains the gelatin surface of the print. The longer the brush point is applied to an area, the darker the staining will become. If the brush is too wet, a water and dye bubble may appear on the surface of the print. A sponge is used to absorb the excess moisture. It is best to work with as dry a brush as possible—one that will still support a pointed tip—and to work from dark to light areas. To check the correctness of the dye tone before beginning the spotting, use the white saucer as a guide. A better method is to use the white margin of a print that will be dry-mounted. The margin has the same white as the dust spot, as well as the same reflective qualities.

Should a print be spotted before or after dry mounting? If resin-coated paper is used, spotting before dry mounting can be done easily because the print lies flat. With fiber base, there is often too much paper curl to make spotting easy. One suggestion is to first flatten the print in a dry-mount press and then use an overmat to hold the print flat.

Spotting done after a print is mounted encourages more care, since a mistake can ruin a print and the mounting effort. Spotting is done best with the aid of natural window light or strong sidelight from an adjustable lamp. Use of overhead lights tends to create shadows, cast from the hand holding the brush.

Mounting the Print

Photographs planned for exhibit must first be mounted or affixed to display board. This is done to keep the print flat, protect the edges, and provide a suitable environment for viewing.

Display methods include mounting prints on boards larger than the size of the print, flush mounting, and window matting, also called overmatting.

The most durable of several methods to attach the print to the board is called dry mounting. A piece of thermoplastic material, called dry-mounting tissue, is attached to the back of a print with heat from a tacking iron. The print and the tissue are then trimmed together, tacked securely to the display board and placed in a heated dry-mounting press until the tissue bonds the print completely to the board.

selecting a board

Display boards generally fall into three categories, depending on the display conditions or the need for archival permanence.

The least expensive board is a poster board. It is quite flexible, thin, and susceptible to corner damage.

Dry-mounting Materials
Standard dry-mounting equipment and supplies include a tacking iron, steel rule or straightedge, trimming knife, pencil, mounting board, mounting tissue, and a dry-mounting press or a household iron at a setting between silk and wool.

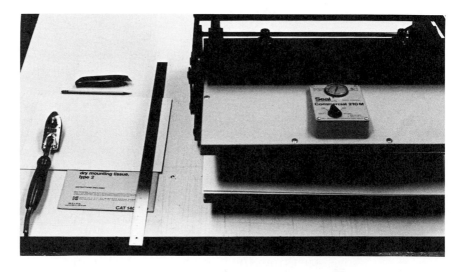

A better board is called illustration board. It is a pressed variety, meaning that a good display surface is layered over a backing material to provide durability. Examples include such brand names as Crescent or Bainbridge.

A third type is 100 percent rag board used for the finest of prints when both archival permanence and/or overmatting are desired.

Mounting boards should have a clean white tone and a flat surface. Avoid pebbled boards since they tend to compete with image values and surface texture.

Some photography stores sell precut board. Many photographers take advantage of this since machine trimming is more true and saves time. However, most precut boards are of poor quality.

Better quality boards are only available in large sizes, such as 32 × 40 in. These boards have to be cut to a size suitable for the print. A sharp razorblade knife and a good straightedge or T square are essential if clean, straight cuts are to be made.

mounting resin-coated papers

While mounting technique for all papers is similar, special precautions must be observed when mounting resin-coated papers. First, a mounting tissue must be of a type specified for resin-coated papers. Then a special nonstick silicon moisture-releasing paper blanket, or a good brand of kraft paper, must always be placed between the print and the heating surface of the mounting press or iron.

Mounting temperature is also critical. Most resin-coated papers can be mounted safely at about 180° F. Higher temperatures can result in mottling or burning of the resin coating.

mounting fiber-base papers

A major concern with fiber-base papers, especially single weight, is the need to have the print lie flat before any trimming or mounting takes place. This can be done best by first placing the print in the dry-mount press for about 30 seconds. Residual moisture is then driven out. Failure to do this can result in prints being trimmed crooked, or worse, in the mounted print being wrinkled.

Mounting temperatures for fiber-base paper are higher (250° F) than for resin-coated papers (180° F). In addition, a different type of mounting tissue is required.

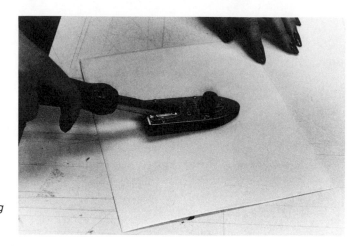

Tacking Iron
Mounting tissue is first applied to the back of an untrimmed print by heating the center of the print with a tacking iron.

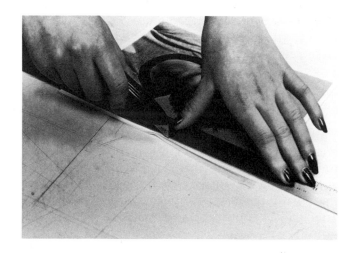

Trimming the Print
The print is trimmed after the tissue has been applied with the tacking iron. The result is a print edge where the mounting tissue does not show.

Attaching the Print to the Board
Before the print is attached to the board, the board is placed in the dry-mount press for about 30 seconds in order to remove excess moisture. The print is then attached to the board at diagonal corners with the tacking iron.

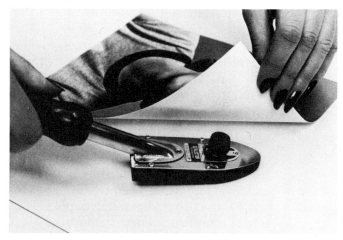

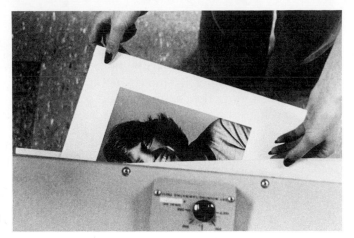

Inserting Print into Mounting Press
The print and board are heated to-gether for about 15 seconds. After the print and board have been heated, re-move the board and place a weight on top for a few seconds.

mounting procedures

Equipment needed includes the proper dry-mounting tissue, display board, metal straightedge, T square or carpenter's square, a replace-able blade knife or sharp trimmer, tacking iron, and dry-mounting press. A home iron may also be used.

1. Trim the board. Board sizes are arbitrary, but it may be easier to establish a portfolio or a series of prints for display purposes if the board size is kept constant. Many photographers establish a pattern that places an equal amount of white space at the top and the sides and a slightly longer board length at the bottom. For ex-ample, a pleasing size for an 8 × 10 in. trimmed vertical print might be a 2-inch space at the top and sides and a 3-inch space at the bottom. The board size would then be 12 × 15 in.

The board should be trimmed cleanly, using a sharp knife, and a good metal edge. All trimming should be done with a piece of scrap board placed under the board to be trimmed. Failure to do this can dull a blade quickly.

2. Place the trimmed board in the dry-mount press for about 30 seconds to drive out moisture. Mounted prints curl badly if mois-ture remains in the board after mounting. When the board is re-moved from the press, place it under a weight and allow it to cool flat for a few seconds.

3. Next, adhere the print to a piece of the right type of mounting tissue. This is done with a tacking iron in one of two ways. Tack the tissue to the center of the print by moving the tacking iron in a circular pattern. Test to see that the tissue is stuck to the back of the print. Or, describe a cross with the tacking iron, from top to bottom and from side to side. Both methods leave the corners of the tissue free to be attached to the board. The cross method is said to stretch the tissue more evenly from the center outward.

115

4. Now trim the print and tissue with a sharp knife or good trimmer. Remove the borders and any extraneous visual matter. A carpenter's square and a knife work quite well in getting all sides square. If a trimmer is used, square up the edges with the lines on the trimmer board.

5. Position the print on the board. A small plastic T square is helpful in getting the print centered and lining up the print so that the top of the print is parallel with the top of the board. Place a clean sheet of paper over the print to minimize hand oil and dirt. Hold the print down in the center. Next, lift a corner of the print and use the tacking iron to attach the tissue to the board. Without moving the print, lift the opposite diagonal corner of the print and tack the tissue again. This method ensures that the print will not slip from its squared position on the board when it is placed in the dry-mount press. If desired, an alternative would be to tack all four corners. This method works better for resin-coated paper because it is more dimensionally stable than fiber-base paper.

6. Place the print and the board into the dry-mounting press. Use either the release blanket for resin-coated papers, or clean thin board or kraft paper between the heated platen and the print surface. Never allow the print surface to be in direct contact with the platen. On Seal-type dry-mount presses, a resin-coated print will adhere in about 15 seconds. Fiber-base papers will adhere thoroughly anywhere from 30 seconds to 3 minutes.

7. Remove the mounted print and place it under a weight for a few seconds. Then check the print by slightly flexing the board. If the print has not adhered well, a slight cracking noise will indicate that the print must be reinserted in the press and heated again.

Window Mats

Prints considered for display look best when they are matted. The mat is not only esthetically pleasing, but keeps the print from touching glass when displayed in a frame. If a print touches the glass, print moisture may cause the print to buckle and cause Newton's Rings—a concentric band of color caused by light refraction.

Matting may be done with prints already mounted, or a print may be taped to a mat board. A mat's outside dimensions should first be determined. If the mat is cut to fit a frame, allow $\frac{1}{16}$ inch for the mat to expand. If the mat is to be placed over a mounted print, make the mat board a little larger to hide the mounting board.

Next, determine the window size. Use a pair of cropping L's to visualize the final print appearance and to measure for the cut. The

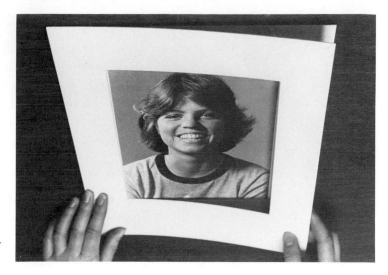

Overmatting
Window mats help give prints a finished look. Window mats are best made with the use of a mat cutter. Prints should be signed and year-dated just below the right-hand corner of the print.

print should be a little larger than the window if the print is to be taped to the window. Avoid masking tape, since it is not permanent and may mar the print. Matting tape is available from art supply stores.

The mat can be cut as a straight edge or on a bevel edge. A straight cut can be done on top of the mat. If a bevel edge is desired, cutting is usually done on the back side of the mat. Bevel cutting is done with a mat cutter. Two inexpensive varieties are the Dexter or the Logan Mat cutter. A kit containing all necessary items is available from Light Impressions Corp., 131 Gould St., Rochester, NY 14610.

The most important point about mat cutting is to secure the square or straight edge so that it does not move when a cut is made. A small C clamp or a good metal T square can provide enough pressure to keep the cut straight. Bevel corners can be cleaned up using an emery board or a fine grit sandpaper. Mat cleanup should be done with a soft gum eraser.

Titling and Signing

Fingerprints and surface dust should be removed before a print is displayed. Gently buff the print surface with a soft cloth. In stubborn cases, a light coat of neutral shoe polish and buffing can help to hide embedded hand oil.

A print is considered finished when it is signed and dated. This is done just below the print on the right side. If a title is desired, use the left side. A soft lead pencil or a good black ink pen can be used for the signature. Do not use a colored ink pen, since the color competes with the print.

8

artificial and existing light

Every photographer tries to control lighting to some degree. In outdoor situations, the photographer exerts control primarily through a process of selection. Should the subject be pictured using direct sunlight, overcast diffused light, or in open shade? Is the time of day correct for the shooting intention? What about subject contrast in terms of lighting contrast and background choice? By waiting for the right time and the right lighting conditions, both creative and exposure control are possible.

An even greater degree of control rests with the photographer who works indoors. The photographer has several options. These include the use of existing window light, continuous light sources, or electronic flash.

Through an understanding of the various light sources, the use of lighting ratios, and various lighting accessories, the photographer becomes creative in the lighting approach to the subject.

Qualities of Artificial and Existing Light

Among the qualities of artificial and existing light are contrast, direction, color temperature, and ultraviolet radiation.

Through contrast, the shape of things becomes apparent. Differences between where the light is falling and where it is not often reveal the texture, detail, and shape of the subject or object. The closer the subject is to a point source, such as sunlight entering

through a window, the more contrast will be created between the subject and the background. As the distance between a point source light and the subject increases, the contrast is reduced.

The direction of the light has much to do with the mood. If the light source is coming from the side, texture, strong contrast, and separation from background are among the more observable results. If the light source is placed behind the subject, the outline or shape is best revealed. If the subject is front lighted, the effect is often one of flattened perspective and reduced contrast.

Another quality of light, color temperature, is often overlooked by the photographer working in black and white. Color temperature refers to the warmth or coolness of the light source. Early morning daylight is a cool source. Candlelight is a warm source.

An incandescent or tungsten light source emits visible light as a filament is heated. At different thermal temperatures, tungsten filament units emit different wavelengths of visible light. These wavelengths are measured in color temperatures of degrees Kelvin ($^\circ$K). Typical tungsten floodlamps emit wavelengths measured at 3400 K or 3200 K. When using color film, lighting sources must be matched to the color balance of the film.

In addition to color temperature, both black-and-white and color films are sensitive to invisible ultraviolet radiation. Unless an ultraviolet or skylight filter is used over the lens, highlight densities in black-and-white film are greater when working with daylight or unfiltered electronic flash. The chief effect in a portrait would be an observable increase in skin blemishes. Since tungsten light sources emit little ultraviolet, portraits made with tungsten light sources tend to have more pleasing skin tones.

Artificial Light Sources

Various lighting approaches can be taken when the photographer works indoors. These can be identified as continuous point source and intermittent electronic flash.

continuous point source: photoflood

High wattage bulbs resembling ordinary household lamps have been available for a long time. They are designed for use with simple reflectors, clamps, or light stands. Occasionally, these lamps are used in household fixtures to light large areas. Always check if wiring and power are sufficient to handle photoflood wattage.

Photofloods are available in three sizes—250, 500, and 1000 watts. These lamps generate a lot of heat, change color temperature as they age, and have a short lifespan. Yet photofloods remain the least expensive and the best way to learn simple lighting setups that are used in traditional portrait lighting.

continuous point source: quartz-halogen

This light source is longer lasting than photofloods. It is available in a power range from 150–2000 watts. The lamp is composed of a thick quartz material that can withstand high temperature. It is filled with a halogen gas that interacts with a tungsten filament to

Various Lighting Modes
Different methods of lighting indoors include quartz and photoflood tungsten sources and daylight-balanced electronic flash. Reflectors, umbrellas, and diffusers reduce lighting intensity and help to soften shadows.

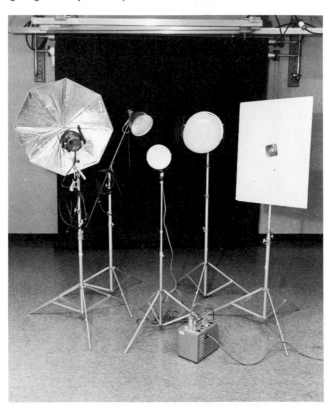

produce a crisp, high intensity light. The color temperature tends to remain even during the life of the lamp. Because of the high heat generated by both photoflood and quartz-halogen lamps, care should be taken in handling the reflectors and lamp housings.

continuous diffused point source

Any point source floodlamp can be transformed into a diffused point source by covering the light with translucent diffusing material or by using lighting umbrellas.

Diffused light is really light reflecting from any source not in itself a point source. Light coming from a reflector board would be a diffused source. In portrait lighting, both diffused point source and diffused light are often used in combination.

intermittent electronic flash

Electronic flash works on the principle of storing electricity in a capacitor and then discharging it through an inert gas to create an intense light. Since the discharge is so rapid, many photographers are unable to see the effect of the light on the subject.

Studio photographers handle this problem by using lighting units equipped with incandescent modeling lights. The lighting effect is first studied with a continuous point source before the exposure is made.

Because of automatic controls built into most portable electronic flash units, a fair amount of lighting control is possible even though the effect of the flash cannot be studied.

Cameras and Accessories

Because of its many advantages, most photographers use a single lens reflex camera for portraiture. The ability to "see" the actual composition, ease of focus, absence of parallax, and the ability to use many different lenses, all play a role in the SLR decision. Some photographers prefer a larger image format available with 120 size film. However, the 120 medium format camera and accessories are considerably more expensive than the 35mm SLR.

SLR cameras equipped with depth-of-field previewers allow the photographer to study the lighting effect with the lens closed down. The darkened image on the ground glass is similar in tone and mood to what one would see in the final print.

Desirable accessories include a medium telephoto or short zoom lens, sturdy tripod, cable release, separate exposure meter, and a gray card.

Different lenses produce different perspectives or angles of view. Because of distortion, most normal and wide-angle lenses are not good for portraits. If a normal lens is placed too close to the subject, the face may appear more rounded and the nose larger in the print than in real life.

If a normal lens is used at a longer distance to avoid distortion, the image size may be too small to make a quality enlargement.

Medium telephoto 35mm camera lenses, 85 to 105mm, offer the least distortion while allowing a comfortable camera-to-subject

Comparison of Normal and Telephoto Lenses
Left: Facial distortion occurs when a normal lens is used too close to the subject. Compare the portrait at right, which was made with a 105mm medium telephoto lens.

distance. A good quality zoom lens can also be used. One disadvantage of a zoom lens is the loss of light as the focal length increases. If light levels are too low, it may be difficult to make an exposure at normal film speeds.

A hand-held exposure meter, preferably with incident light-measuring capability, is desirable for getting close-up readings. When a camera with built-in metering is locked into a location on a tripod, selective meter readings are more difficult.

Using Continuous Point Source Lighting

Traditional portrait lighting consists of a key or main light, a fill light to reduce shadow density, a hair light, and an optional background light.

Establishing the Key Light The key light is placed on a lighting stand and raised about 6 to 8 feet from the floor. It is angled about 45 degrees to the subject. This simulates the natural sunlight angle of midafternoon. If the key light is moved in an imaginary circle from the side of the subject to a point near the camera position, four different lighting positions are possible:

1. HATCHET OR 90-DEGREE SIDE LIGHTING The key light is placed at a 90-degree angle between camera and subject. The effect is a division of the face with a shadow line running vertically through

Figure 8-1 Key Light Positions
In traditional portrait lighting, moving the key light position from 90 to 180 degrees produces different nose shadow effects. If the key light is placed close to the camera, the effect is broad and flat. As the key light is moved toward a side position, the effect becomes more narrow and contrasty.

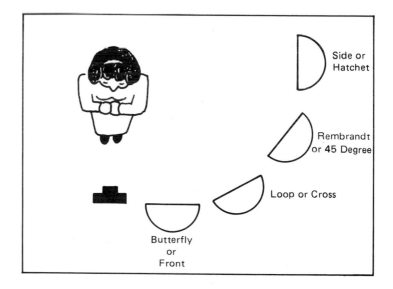

Hatchet or Side Lighting
Hatchet or side lighting is achieved by placing the key light to one side of the subject.

the nose. This is a severe or dramatic lighting approach that makes the face appear both longer and thinner.

2. REMBRANDT OR 45-DEGREE LIGHTING The key light is placed at about 45 degrees between camera and subject. This position causes light to stream across the bridge of the nose. A triangle of light now appears on the dark side of the face. This is dramatic lighting that helps narrow the face.

3. LOOP OR CROSS LIGHTING As the key light is moved closer to the camera position, the triangle lighting effect disappears. Now a distinct shadow extends from the nose. The length of the shadow is determined by nose length and key light position. Loop or cross lighting is perhaps the most convenient and practical for the widest variety of subjects.

4. BUTTERFLY OR FRONT LIGHTING The key light is placed high in front of the subject, next to the camera position. The shadow cast by the light is now directly under the nose and resembles the outline of butterfly wings. This kind of lighting is sometimes called glamour or Hollywood lighting because of its flattering qualities. It works best with oval faces.

Rembrandt or 45-Degree Lighting
Rembrandt or 45-degree lighting places a triangle of light on the shadow side of the face. Shape of the bridge of the nose and height of the key light produce many triangle variations.

Loop or Cross Lighting
Loop or cross lighting shows best when the key light is placed high and closer to the camera. Nose width and length will vary the shape and length of the nose shadow.

Butterfly or Front Lighting
Butterfly or front lighting is achieved by placing the key light high and directly next to the camera position. This often results in a glamorous or Hollywood look.

Using the Fill Light Any discussion of fill lighting involves the need to understand lighting ratios. These are treated under a separate heading on pages 126–128. A fill light serves to lighten the shadows created by the key light, adding both depth and detail to the portrait. The fill light is normally placed at about eye level and near the camera position.

Hair and Background Lights The hair light brings out detail in the hair while adding sparkle to the picture. The hair light also serves to separate the head from the background. Keep the hair light some distance from the hair or the result could be a halo effect.

A background light is an option. Sometimes a light is placed behind the subject to lighten a white background. If a black background is lighted, the effect is a middle to dark gray tone.

Lighting Ratios

A ratio is established when the difference between the key light and the fill light is measured. If a single point source light is used without a fill light, the ratio between highlights and shadows is about 8:1.

Lighting Ratios
A single key light produces, left, deep shadows and harsh contrast at about an 8:1 ratio.
More pleasing results, right, can be obtained with a fill light to reduce the ratio to 3:1.

That is, the highlights are 8 times or 3 f/stops brighter than the light value of the shadows. While the human eye can easily discern this shadow detail, most films cannot. The result is stark highlights and little or no shadow detail.

When a fill light or a reflector board is used, the lighting ratio may fall to more tolerable levels, such as 4:1 or 3:1. Shadow detail can now be recorded on film.

A 3:1 ratio is the most desirable in traditional portrait lighting. It gives good shadow detail while providing effective depth and roundness. A ratio can be determined by any of the following methods:

1. If the key light and the fill light are of the same wattage, move the fill light away from the subject about 2 times the distance that the key light is to the subject.
2. If the key light is of higher wattage than the fill light, metered readings of both the shadow and highlight areas reveal ex-

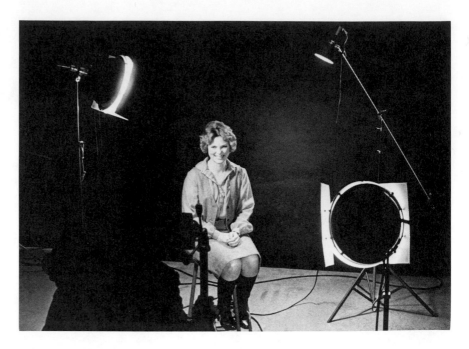

Three-Light Setup
A basic three-light setup includes a key light placed high and to the left or the right of the camera, a fill light at eye level, and a hair or background light.

 posure differences. Move the fill light and make new readings until a difference of 1½ to 2 f/stops is reached.

3. If an overall meter reading is taken with a built-in camera meter, an approximate 3:1 ratio can be established by pre-selecting a lens opening. Convert that lens opening to feet and move the fill light that distance from the subject. For example, if an overall reading from the key light alone gives a good f/stop and shutter speed combination at f/8, then turn on the fill light and move it 8 feet from the subject.

Figuring Exposure

Exposures may be made with hand-held incident light or reflected light meters, or with built-in reflected light meters.

 1. INCIDENT LIGHT READINGS In portrait lighting, it is often more effective to read the light falling on the subject. The meter is aimed at the camera from the subject position.

2. REFLECTED LIGHT READINGS A reflected light meter will work as well as an incident light meter when the meter is aimed at an 18 percent gray card placed at the subject position. An incident light meter measures 18 percent of the light falling on the subject.

3. METERING FROM CAMERA POSITION Since subject distances from the camera may make it difficult to take specific readings from a gray card, or if a gray card is not available, the exposure can be made in one of two ways. First, try to read only the fill-lighted or shadow side of the face. Make an exposure based on that value. Second, if an average reading is taken, open up the lens one more stop than the indicated reading. This is done in order to put more density into the highlights. This produces whiter flesh tones with Caucasian subjects. If the subject is non-Caucasian, close down the lens by one f/stop from the indicated exposure. This reduces highlight exposure and renders flesh tones darker.

Using Diffused Point Source Lighting

The simplicity of using nearly shadowless umbrella or soft box lighting probably accounts for its continuing popularity. This form of lighting is seen often on television commercials and in magazine advertisements. It allows the photographer to capture a variety of movements and expressions without the subject's face being lost in shadow.

Any point source light can be converted into a diffused point source with the addition of diffusing materials. The most popular methods include umbrellas, soft boxes and fluorescent light banks. In addition, a variety of reflecting boards and surfaces can be used as diffused fill light.

1. UMBRELLAS While there are some minor differences in styles and reflectances, most photographic umbrellas resemble standard parabolic rain umbrellas. Others have a square design that doubles as a flat surface reflector.

If a single umbrella is used in portrait lighting, it is better to keep the umbrella near the camera and above the subject's head. The lower edge of the umbrella should be just above the camera. In this position, the softest and most shadow-free lighting is possible. There is little need for a fill light. When an umbrella is moved to the

side, it behaves like a point source, casting soft shadows and creating some texture.

Umbrellas are available in various sizes as well as in translucent or opaque material. A translucent umbrella can be used both as a reflector and as a transilluminator. Umbrellas with an opaque white surface have high reflectance as do umbrellas with metallized or foil surfaces. Foil-type umbrellas produce contrasty light and occasional hot spots.

2. SOFT BOX LIGHTING An impression of soft, shadowless window light can be achieved when working with a soft box. A simple setup can be constructed from cardboard, aluminum foil, and translucent diffusing material. The box is then fitted with a fluorescent tube or electronic flash source. Most tungsten sources are too hot for continuous use with a homemade box.

3. BOARD REFLECTORS The simplest and easiest to manage board reflectors are those made of white foam, commonly called Foam Core. They weigh little and can be clamped easily to a light stand or hung from a ceiling hook. They produce an even white reflectance and work well in combination with window light or with tungsten or flash sources.

Umbrella Lighting
Umbrella lighting is popular because it creates an open, nearly shadowless feeling that is flattering to the subject. Umbrella lighting can be adapted to both tungsten or electronic flash sources.

Lighting with Electronic Flash

Of all the lighting options available, electronic flash is both the most troublesome and requires the most knowledge of lighting. Yet, it is the preferred artificial lighting method for most beginners. This is because it is inexpensive, portable, and convenient. What plagues many beginners is the failure of the flash to fire at critical moments, or the photographer's failure to synchronize the flash to the camera's shutter system. And, because the flash duration is so short, the effect of the flash on the subject is almost impossible to see.

Electronic flash units are available in several price and power ranges. Most units have automatic as well as manual firing modes. The more expensive units also have variable power options that allow control of lighting ratios when working with daylight or with multiple flash. Some units are made specifically for a particular camera. These "dedicated" units set the proper shutter speed automatically and calculate the right amount of light for proper exposure.

The mechanics of understanding and using flash include synchronization and exposure calculation.

flash synchronization

Flash exposure is based on flash-to-subject distance and film speed. The shutter plays no part in the exposure, except to act as a synchronizer for the flash. This means that the flash emission must coincide with the full opening of the shutter if all parts of the picture are to be exposed evenly.

In general, cameras equipped with focal plane shutters synchronize with the electronic flash at the following speeds:

$1/60$ second—Horizontal traveling cloth or metal curtains
$1/90$ second—Newer electronic metal blade shutters
$1/125$ second—Vertical traveling metal blade shutters

synchronization symbols

Cameras are equipped with various synchronization terminals. For electronic flash, the letter X or a zigzag arrow is used to indicate the flash terminal that synchronizes with an electronic flash unit. On many 35mm cameras, a "hot shoe" located at the top of the camera provides a direct, wireless electronic flash contact point.

If flashbulbs are used, such designations as M for medium peak

bulbs or FP for focal plane flashbulbs indicate where the electrical circuit is to be made. If the wrong contact is used, the flash may still fire, but little or no light will reach the film.

calculating exposure

Most electronic flash units are measured for their light power by beam candle power seconds (BCPS). Studio units are rated at capacitor storage ability in watt-seconds. Portable units are rated by a guide number which is related to film speed.

For most amateur applications, whether the unit is used in automatic or manual mode, the film speed must be found on the flash exposure dial and an appropriate distance range and f/stop found.

In manual mode, if an ISO 125 film is used, this number is placed into the exposure computer of the flash. Then the photographer calculates the distance the flash light must travel to reach the main subject. That distance is divided into the guide number and gives the lens opening for the proper exposure. Let's say that the distance from the flash to the main subject, using ISO 125 film, is 10 feet. Divide 10 into the guide number for ISO 125 film. Let's assume that the guide number is 110. Divide 10 into 110. The result is an f/number of f/11.

Flash units with automatic sensing usually indicate a distance range, such as 10–15 feet, and specify an f/stop for that distance range. Simply set the lens for that opening. The flash will adjust its light output for that distance.

multiple flash

If two flash units are used to light a scene, an exposure ratio must be calculated. To achieve a desirable 3:1 ratio, the same procedure is followed as that described earlier for key and fill tungsten light sources.

A handy item for two-light flash setups is a slave unit. A slave is an electronic sensor that is attached to the remote flash. When the flash attached to camera is fired, the slave sees this light and activates the remote flash. Since light travels so fast, the result appears to be an instantaneous firing of both units. The advantage of a slave is that no wires are needed to make an electrical connection between the two units.

flash lighting problems

Most amateur flash units are attached to the camera directly by means of a hot shoe. While this makes the camera and flash extremely portable and convenient, the lighting result is often too contrasty. Ugly shadows are created if the subject is too close to a wall. In addition, if the flash and camera are held at subject eye level, a condition known as "red eye" may result. With color film, the subject may show a blood red iris that can be disconcerting. With black-and-white film, a graying over of the iris may be seen. The only cure is to change the flash-subject position. One method is to use an electronic standoff that is slipped into the camera's accessory hot shoe. A flash cord is then used to connect the flash to the camera's firing mechanism. The flash can now be held in the air and the angle of the flash pointed downward, as in sunlight. The result is a more pleasing natural lighting appearance.

bounce flash

Newer flash units are equipped with swivel heads that allow the flash output to be bounced more easily off walls or ceiling. If the flash is used in automatic mode, the extra distance the flash light must travel to reach the subject is automatically calculated for a particular lens opening. In manual mode, the lens is usually opened two f/stops more than a direct flash-to-subject distance exposure. Bounce flash is softer and less contrasty than direct flash. However, the loss of light intensity through increased distance may be a problem when working with slow speed film.

daylight flash exposure

In some cases, electronic flash units can be used outdoors to soften shadows caused by direct sunlight. The chief problem is the slow shutter speed necessary to synchronize the flash. Slow shutter speeds do not work well in bright light situations unless strong filters are used to reduce the intensity of the light traveling through the lens. This is more of a problem with horizontal-travel focal plane shutters with their slow synchronizing speeds.

Estimating lighting ratios outdoors may be difficult unless the flash unit is equipped with a variable power function. Generally, a 3:1 ratio is achieved by selecting the f/stop for daylight exposure that

is matched to the synchronizing shutter speed. The variable power of the flash is then adjusted for that f/stop.

Flash lighting requires much practice and more than a little camera-handling knowledge for the results to be consistent. Most flash units come with detailed instruction pamphlets. These should be read thoroughly.

One final word. An electronic flash unit should be handled carefully in any situation where rain or moisture are present. Electrical shock from high voltage units can be hazardous.

9

composition

Beginning photographers may wonder if there is a formula for successful picture taking. None exists, although many have tried to define success through so-called "rules of composition." These rules have their history, deriving mainly from painting.

Successful photography is more likely the result of experience, enthusiasm, sensitivity, and awareness. Since photography is one art form with an unlimited array of mechanical, technical, and esthetic approaches to subject matter, the photographer has many options. Some of these are considered below.

The Photographer's Options

1. *Film format* The small and convenient 35mm film size works better in people and action situations. Larger formats are often better for landscapes and for critical detail.

2. *Lenses* The approach to the subject may be optically widened, magnified, zoomed, distorted, or simply recorded in normal perspective.

3. *Camera position* Pictures are often made from an eye level position. Other viewpoints are possible by shifting camera position.

4. *The background* Relationships between subject and background are highly important. The photographer interprets this re-

Changing Camera Position
Perspective involves moving the camera position rather than changing the lens. At left, the image is a normal eye-level perspective or point of view. The image at right was made from a slightly elevated perspective looking down on the subject.

Foreground Emphasis
Foreground emphasis relates to the background. Selective focus and careful use of depth of field create a three-dimensional effect.

lationship and sometimes minimizes the background through selective focus and subject placement.

5. *The right lighting* The time of day and the direction of the light often affect the intent or the mood of the scene.

Frame Emphasis
The frame emphasis works best when it complements the flow of the image. Here, a vertical emphasis reinforces the bridge pilings. (See next page.)

A horizontal emphasis (above) flows with the railing line. Below, strong horizontal and vertical elements are juxtaposed against a square frame.

6. *The frame emphasis* Sometimes a horizontal emphasis is best, as with many landscapes. Sometimes a vertical emphasis is used with people, while a square emphasis can fit a variety of situations.

7. *Positive and negative space* The relationship between the subject and what the subject rests on can be controlled. A large area of negative space, such as a clear sky or empty foreground, may enhance feelings of isolation or create a feeling of large scale. Minimizing the negative space can result in more attention to detail.

8. *The spontaneous moment* As beginners sharpen their perceptions, picture possibilities appear to be everywhere. They may be juxtapositions caused by subject placement, kind of lighting, or time of day. They are often spontaneous moments. Move a few feet and the subject-background relationship changes. Or, the light may be right for only a short time. Many of these moments occur in people situations. To capture these, the camera must be prepared to respond as quickly as the response in the mind's eye.

Negative Space
Negative space is a strong force in this silhouette photograph.

Spontaneous Moment
Spontaneous moment photographs call for the mind and the camera to be
ready to respond at the same time.

Differences Between Eye and Camera

You should recognize early in mastering photography that the image seen with the eye and that seen in the print have little in common. They certainly resemble one another. Yet the differences are significant.

The print represents a departure from normal seeing. It is a heightened awareness and a deeper concentration of visual senses because of the picture frame. The frame isolates and concentrates the photographer's intent. The frame removes the context and conditions under which the scene was originally viewed.

A review of the differences between eye and camera (see Table 9-1) shows that the photographer must develop a special sense of seeing, one related to how the camera sees.

TABLE 9-1 Differences Between the Human Eye and the Camera and Film

THE HUMAN EYE	THE CAMERA AND FILM
1. Sees three dimensions	Cannot see depth, only height and width
2. Sees only a "normal" image	Has interchangeable lenses that produce different image sizes, relationships
3. Cannot slow action	Has a shutter to stop action or allow blur
4. Can see image in only one size	Through different lenses, various magnifications are possible
5. Is selective, seeing only what it chooses to see	Is objective, records everything the film speed allows
6. Is sensitive to color and sees color normally	May alter the coloration or translate color into shades of gray
7. Cannot store light	Through time exposure may record images not able to be seen with the eye
8. Is sensitive only to the visible light spectrum	With special films can also see infrared, ultraviolet, or X-ray
9. Cannot retain or combine a number of images	Can double expose or produce special effects with filters and masking
10. Accepts apparent convergence of parallel lines	Produces convergence but can be annoying when compared to frame edges. Can be corrected with some cameras and in the enlarger.

Some Common Problems with Composition

Failure to separate the background from the subject is a common problem with composition. This separation may be accomplished through (a) selective focus, (b) changing the subject's position, or (c) providing more contrast between subject and background. Selective focus and aperture control can soften backgrounds a bit to make the subject element stand out in sharp relief. By shifting the camera position from eye level to a high or low angle, visual interest may be obtained with the most commonplace subject matter. Finally, by being more aware of subject tonality and background tonality, tone mergers can be avoided.

Another common problem with composition is the failure to look at the edges and the corners of the composition. It is important to eliminate distracting elements that do not contribute to the picture's intent.

The failure to separate the background by selective use of light-

ing is a third composition problem. Many beginners photograph with the sun behind them. Instead, sharp separation can be achieved through subject backlighting or through side lighting.

Helpful Hints in Composition

Not all of the following apply in any given visual situation. Yet, experienced photographers develop an instinct in their approach based on these visual controls:

1. Avoid tone mergers—subject and background should separate easily.
2. Try for a single center of interest. Too many distracting or equal visual elements may cause the viewer to wander.
3. Include foreground in landscapes to create an illusion of space.
4. Avoid dividing the picture into equal parts. Main centers of interest are often more effective slightly off center. Watch for the "dead center" syndrome with 35mm SLR cameras.
5. Let action lead into the picture area from left to right.
6. Keep subject matter simple by moving closer.
7. Previsualize the tonalities of the image by using the depth-of-field previewer or squint the eye to simulate what the image will look like using a small f/stop.
8. Use hands as a viewing frame and close one eye while viewing. The subject-background relationship becomes obvious because it is seen life size.
9. Be aware of surroundings that influence the image. The print is seen in isolation, while the original scene is not.
10. Try to work from front to back with the image, rather than from side to side.
11. Compose the picture in the direction of the main visual elements. A horizontal frame is often better for landscapes, while people and cityscapes may benefit from a vertical frame.

The Print and the Image

The print may be true to the original intention of the photographer, or the print may be altered to change the intention. However, the print really cannot change the original point of view or perspective, nor can it change the relationship between light and shadow.

The photographer can heighten the impact of the print through

(a)

Cropping for Emphasis

(a) A photograph as it was printed; (b) cropping L's used as part of postprinting finishing technique to improve the composition. The cropped print (c) is shown on page 144.

(b)

the direction of the image (vertical, horizontal, or square) and through cropping to tighten the elements and put more strength at the edges.

Printing should try to contain the edges and keep small white areas from creeping into the margins. By using a set of cropping L's when viewing the contact sheet, the enlargement can then be brought into a close approximation of the original intent. A larger set of cropping L's may be used for fine tuning the edges before a print is mounted.

10

technical and stylistic developments

It is hard to imagine a more exciting response in any century to technological change than when the French people in 1839 were presented with the first practical photographic process. They saw for the first time on a silver and copper plate all of the detail reproduced precisely as nature had formed it.

In a relatively short period of about 160 years, photography has progressed from a time in 1826, when the first picture ever made called for an 8 hour exposure, to today's cameras that can record an image in as little as $\frac{1}{4000}$ second!

Photography was quickly and universally accepted as a great technical development. But when the medium sought its place as a unique art form, the art community rejected it. Today, photography is honored in the universities, patronized in galleries and museums, and eulogized when one of its aging heroes passes on.

The authors acknowledge that photography's complex though short history cannot be detailed in any but the most general of terms in these few pages. Yet, students should at least be aware of the major technical advances and the broad stylistic themes or trends that have influenced the medium.

Early Technical Developments

Photography as we know it today is a picture-making system using a camera and light sensitive materials. But camera pictures have existed for at least 400 years, in the hands of artists using the camera

obscura to help solve their perspective problems. The photographic camera is a direct descendent of the camera obscura.

camera obscura

Leonardo da Vinci, the gifted fifteenth-century artist and inventer, explained in his writings and drawings the principles of the camera obscura (Latin for dark chamber or room). It was a darkened room where the only light admitted came from a tiny hole in one wall. On the opposite wall could be seen an inverted image formed from the scene outside as its light waves passed through the tiny opening. Artists placed paper over the image and traced its outlines. In the eighteenth century, the camera obscura was improved with the addition of mirrors and lenses and constructed in smaller sizes for field portability.

photochemistry

Scientists sought for many years to fix by chemical means the images seen through the camera obscura. In 1725, a major discovery was made by Johann H. Schulze, a professor of anatomy in Germany. He discovered that silver salts are sensitive to light. He filled a flask with a mixture of chalk and nitric acid and placed the bottle in direct sunlight. The mixture turned dark purple. He proved that the discoloration was due to the action of light on silver nitrate, rather than the effect of heat or exposure to air. The silver nitrate was a contaminant in the nitric acid he had used. The discovery of the darkening of silver salts by sunlight is the basis of the photochemical process.

Carl Wilhelm Scheele, a Swedish chemist, discovered in 1777 that silver chloride turned black when exposed to sunlight. He found that silver chloride was soluble in ammonia, while silver was not. Scheele's experiment was a major step toward producing a permanent image.

Thomas Wedgewood, son of the prominent British potter Josiah Wedgewood, experimented in the late 1790s with making "sun prints" on paper coated with light-sensitive chemicals. These images promptly faded and turned black. Even though the images faded, Wedgewood was on the right track. He had placed a piece of lace on paper soaked in silver nitrate and exposed it to sunlight. What he produced was an image that was a reversal of the subject—a negative print. Unfortunately, Wedgewood could not permanently fix the im-

age. Eventually, the entire piece of paper would blacken and the image would disappear. Yet, the negative-positive relationship would survive to become the basis for most of photography.

In 1826, Joseph Nicéphore Niépce, a French engineer, was the first person to make a permanent image, but he did it without silver. He discovered that certain asphalts hardened when exposed to light. He placed a coated metal plate in a portable camera obscura. Following a lengthy exposure estimated at eight hours, Niépce immersed the exposed plate in a weak acid solution, which allowed the exposed areas on the metal to be etched, while the unexposed asphalt was dissolved. Niépce's first photograph shows the view of a courtyard from his second floor window, but only in terms of areas of light and dark tones. The subleties and nuances as we know them from silver could not be reproduced.

A French painter known for his diorama light shows made with huge translucent paintings heard about Niécpe's first photograph. He was Louis Jacques Daguerre, a man who used the camera obscura to trace objects for his shows and who sought a way to make permanent images. Daguerre and Niépce became partners to improve the process. Not much progress was made and in 1833, Niépce died.

Two years later, Daguerre discovered that an exposed iodized silver plate developed in mercury vapor would produce a visible image. He made the image permanent with a bath of common salt by dissolving any unexposed silver iodide that lay on the silver plate.

Four years later, Daguerre announced the details of his process. August of 1839 is generally accepted as the beginning of photography. There was an immediate demand for daguerreotype photographs. Within two years, every major city in Europe and the United States had at least one portrait studio.

In 1841, William Henry Fox Talbot patented his "calotype" process. The process utilized gallic acid as a developing agent and fixing with sodium thiosulphate, today's hypo. This fixing agent was discovered in 1819 by Talbot's friend, Sir John Herschel, a famed English astronomer.

The calotype image was the exact reverse of the original image, a negative. The paper negative process allowed the photographer to make unlimited numbers of positives by simple contact printing in strong sunlight.

Another Englishman, Frederick Scott Archer, made public in 1851 his successful method of making images called the collodion or wet plate process. He used glass plates to hold the emulsion, called collodion. This is a compound of nitrocellulose, ether, and alcohol.

The collodion and a salt, potassium iodide, were carefully poured on a glass plate. The collodion mixture is sticky when wet and would adhere to the plate when it was sensitized in a bath of silver nitrate. Development in pyrogallic acid took place immediately following exposure.

Wet plate photography was a gigantic undertaking. The photographer needed glass plates, camera, tripod, chemicals for sensitizing, developing, and fixing, and a dark tent. Some used a horse-drawn wagon as their darkroom.

In 1856, Hamilton L. Smith patented the tintype process. He used a thin metal plate that was painted dark brown or black to support the collodion mixture. Tintypes were still one of a kind images like the daguerreotypes, but were so inexpensive that they were associated with the penny arcade and instant photography. Because of the dark painting, collodion negatives were seen as positives on the tintypes.

Richard L. Maddox introduced the dry plate process in 1871 by replacing the wet collodion with gelatin. The dry plate process

Tintype
The first practical and inexpensive method of making portraits for the masses was the tintype. A cheap metal plate that was painted black served as the backdrop for the collodion emulsion to produce "instant" portraits in the penny arcades. The crudely cut metal was usually inserted into a finishing frame of velvet and bright metal, or paper.

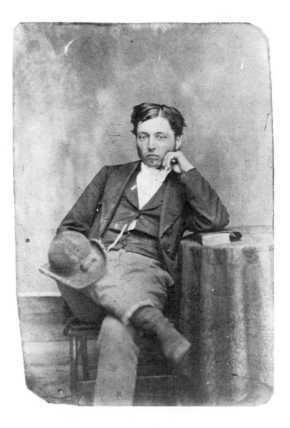

did away with the need for a portable darkroom, allowing the photographer to leave his exposed plates for later developing and printing.

In 1884, George Eastman and W. H. Walker invented the roll film system of photography. The sensitized emulsion was first coated on paper rolls and loaded into the camera. Later a cellulose base was used to support the emulsion.

Eastman manufactured small cameras to use the new roll film. He coined the word Kodak for his cameras and the slogan, "You push the button and we do the rest." This referred to his 100-shot camera that the customer returned to the factory where the exposed film was processed and printed and the camera reloaded and returned. The Kodak camera system made photography accessible to everyone. The era of amateur photography had arrived.

Historical Cameras
Cameras represent the more obvious changes in the history of photography. On the left are a 1925 Ansco box camera and a 1914 Auto Graflex, Jr. In the center (on tripod) is a 5 × 7 in. Seneca Model 9 folding camera made in 1901, a 1940 4 × 5 in. Anniversary Speed Graphic, and a modern 35mm SLR Nikon FM. At right are a Rolleicord III twin lens made in 1950 and the first Polaroid Land Camera—a Model 95 made in 1948.

19th Century Developments

Public demand for permanent images was insatiable following the announcement in France in 1839 that Louis Daguerre had perfected a permanent photographic process he called the daguerreotype. These early images were quite faint, appearing when viewed on a polished copper and silver plate coated with a light-sensitive silver compound. The image could be seen only when viewed at an angle.

In England, a short time later, William Fox Talbot was announcing his calotype process, a system of negatives and positives that would prove to be the direction photography would ultimately take.

In 1851, Frederick Scott Archer developed a more sensitive wet collodion glass plate process that overcame the dual disadvantage of the daguerreotype, namely that of slow speed and the impossibility of making duplicate images from the original plate. The wet plate process also overcame the poor quality of the calotype paper negative.

Photographers, carrying as much as 120 pounds of chemicals, glass plates, camera, tripod, and light-tight tent, were roaming the

Stereo Viewer
Before the U.S. Civil War, the stereographic viewer and stereoscopic views from all over the world were part of most American households. Stereo pictures were made possible by the development of the collodion, or wet plate, process.

world and recording all of its wonders. Public demand for stereotype views created an entire industry. Photographers recorded the pyramids and the wars fought in the Crimea and in the United States. They ranged west with the earliest federal survey teams to document the grandeur of Yosemite and Yellowstone, as well as the adobe dwellings of southwest Indians. In the cities and even small towns, portrait studios flourished, providing permanent likenesses for everyone.

The development of the dry plate in 1871 and George Eastman's perfection of the Kodak hand camera and roll film less than a generation later made the act and the art of photography possible for everyone by the turn of the century.

Major photographic movements or trends of the time concentrated on views and documentation, or were made to imitate earlier art forms, namely painting.

Some of the earliest attempts to imitate painting were symbolic story telling or allegory. O. J. Rejlander's massive photographic montage, titled "Two Ways of Life," and Henry Peach Robinson's "Fading Away" were typical of the many efforts to create staged, painterly effects with the camera.

In the late nineteenth century, photography moved toward naturalism as exemplified in the works of Peter Henry Emerson in the East Anglican marshes of England. The new platinum printing papers helped produce a marvelous range of tones quite in tune with the subtleties of landscape photography.

1900–1920: Growth of a New Art Form

This period is known for its ferment of change brought on by world upheaval and technological improvements in many fields, including photography.

The period is best represented as a departure in photography from the classical pictorial traditions found in painting to a more realistic approach in which the straight, unmanipulated print was emphasized. The major figure in this movement was Alfred Stieglitz.

Stieglitz is one of the giants of photography. He was converted to photography while studying engineering in Europe. Independently wealthy, Steiglitz had little time or patience with the commercial aspects of photography. His great energy was devoted simply to the recognition of photography as a legitimate art form with its unique qualities.

In 1902, he organized the Photo Secessionist movement in New York and broke with strictly traditional painterly photographic rep-

resentation. He founded *Camerawork* magazine, devoted exclusively to the reproduction of straight photography, which later introduced modern European art to America.

Stieglitz single-handedly arranged for a show of the Photo Secession work in 1910 at the Albright Museum in Buffalo, New York. This was the first major exhibit of photography in an American museum. Among the Photo Secessionists were Edward Steichen, Paul Strand, and Clarence White. All were to have a significant influence on the next two generations of photographers.

While people like Stieglitz, Steichen, and Strand were influencing communities of art and artists, mainstream photography hardly noticed. On the streets, photographers like Lewis Hine and Jacob Riis were documenting immigrants, housing conditions, and child labor. In Paris, Eugene Atget worked privately to record the streets of Paris, and Jacques Henri Lartigue left a priceless heritage of photographic documentation of the rich in the days before World War I.

1920–1940: An Age of Experimentation and Photojournalism

This was a period of intense excitement and creativity in all of the arts. Perhaps the dominant influence in photography was that of a consortium of artists in Germany, known as the Bauhaus.

A major Bauhaus figure was Lazlo Moholy-Nagy, who founded the Bauhaus photography department in 1923. Due to political pressures, the Bauhaus, under Moholy-Nagy's leadership, relocated to Chicago in the late 1930s and later became the famous Chicago Institute of Design.

The Bauhaus influence included photographic experimentation and the surrealism of photographers like Moholy-Nagy, Aaron Siskind, and Harry Callahan. The use of cameraless photographs called photograms, and montages and experiments in multiple image printing served as interesting counterpoints to the growing documentary and photojournalistic efforts of the federal government and of several new picture magazines.

The Farm Securities Administration served as a catalyst to document the wounds of the Depression. Among the more famous FSA photographers were Walker Evans, Dorothea Lange, Russell Lee, and Arthur Rothstein.

The public was also fascinated with the new picture magazines, such as *Life* and *Look*. The works of Margaret Bourke-White, Alfred Eisenstaedt, Leonard McCombe, and others in this pretelevision age brought the world closer to everyone.

The 1930s also saw the establishment of a group of West Coast photographers known as the f/64 Group. Rather than work in the experimental and surrealistic genre as did the Bauhaus, the f/64 Group worked toward the straight photograph of extreme sharpness, clarity, and depth. The group included such influential photographers as Edward Weston, Ansel Adams, and Imogen Cunningham.

On the streets, in the halls of government, and in the night life of Europe, small camera documentation was being done as the forerunner of future street photographers. These people included Erich Salomon, Andre Kertesz, Henri Cartier-Bresson, and Brassai.

1940–1960: Personal Visions

The major photojournalistic and documentary work begun late in the 1930s continued well into this period. Improvements in film speed, faster lenses, and a trend toward smaller cameras made street photography highly popular. Among the more noted of the personal vision street photographers were Henri Cartier-Bresson and Andre Kertesz.

Major photo essays continued to be produced for the large picture magazines by Bourke-White, Eisenstaedt, W. Eugene Smith, and Brian Brake. Smith's "Spanish Village" and Brake's "Monsoon" are outstanding examples of the photo essay.

Among the many war photographs of startling realism were those of Robert Capa, W. Eugene Smith, Edward Steichen, and David Duncan.

In the esthetic idiom, photographers like Minor White were advancing the concept of previsualiation and zone exposure and development. White, who developed the photography program at Massachusetts Institute of Technology, spent many years expanding the photographic equivalent statement explored earlier by Stieglitz.

Bill Brandt in England was producing photographs of figure studies unlike anything seen before. His *Perspective on Nudes*, first printed about 1940 and reprinted in 1961, remains a classic.

Wynn Bullock, a friend of Edward Weston, was creating a strong series of landscapes and figure studies based on concepts of space and time and that of opposites.

Harry Callahan was continuing in the tradition of the Bauhaus and began to use experimental viewpoints in his street photography.

It might be said that the highly popular "Family of Man" exhibit organized by Edward Steichen and held in New York in 1955 spelled the end of an era in photography. The public had by then become thoroughly acquainted with the exciting photo essay, the dramatic

"decisive moment" quality of many street photographs, and the majestic scenery photographs of Ansel Adams and others. Change appeared in the form of work by Robert Frank, Diane Arbus, and others.

1960–1975: Conceptual Expansion

This more recent period of photography represents a significant departure from the documentary and straight tradition of photography. It was a turning from formal graphic presentation, in terms of traditional compositional values and subject matter, to more of a psychological involvement with camera and subject. The period deals more with spatial ambiguities and uncertainties than it does with literal meaning.

Early leaders in the movement include the Swiss-born American Robert Frank, Diane Arbus, Minor White, Gary Winogrand, and Lee Friedlander. Photography critic Susan Sontag described Frank's work as "waiting for the moment . . . to catch reality off-guard" in what Frank calls the "in-between moment."

Arbus built a significant cult following from pictures of the bizarre that included voyeurism, perversion, and disfigurement. Minor White utilized his form of the equivalent photograph to wander into the realm of mystical abstraction. Street photographers like Winogrand and Friedlander portrayed a new "urban landscape," full of isolation and psychological searching as found in store window reflections and scattered pieces of urban chaos.

In the West, many photographers converged on the new industrial landscape found so typically in California. Others, like Bill Owens, concentrated on the effects of suburbia, showing ambiguous and confused suburban families.

Photographers like Bruce Davidson extended and added to the the richness of the street document with his highly acclaimed *East 100th Street* essay.

The age is also noted for a good deal of photographic manipulation and symbolism of images as represented by the work of Jerry Uelsmann and Duane Michals. Younger photographers also began to rediscover formerly used processes of platinum printing and gold toning. They also eagerly accepted the experimental qualities of the SX-70 Polaroid print, xerographic prints, and photo silkscreen.

It was also a period where photo galleries increased in number and traditional art galleries began to mount photography exhibits as routinely as any other art form. Prices for early classic works

soared, often outstripping comparable work in other art fields. Photography gained academic respectability, too, with degrees being offered by many of the major universities.

Finally, it was an age of incredible sophistication in cameras and materials as well as major advances in printing technology that made the picture book a commonplace item on many living room and office coffee tables.

Post-1975 Developments

The psychological and surrealistic photography of the recent past seems to be giving way to several possibilities. One is the greater use and acceptance of color, especially in the galleries and in magazines and books. The color photographs of William Eggleston, Stephen Shore, Joel Meyerowitz, Marie Cosindas, and Peter Turner are much in demand.

Another movement is seemingly a time skip, where many photographers are rediscovering the landscape and the use of the larger view camera.

Recent technological developments include autofocusing zoom lenses, 1000 speed color film and light weight color video cameras, continue to push photography into directions no one can foresee. The current rapid social and political changes are also irrevocably mixed in with rapid technical change. Images made in the future will be as different to us as the photographs that were made more than 100 years ago. While it is important to keep an open eye regarding changes in technology, it is equally important not to lose sight of the need to express ourselves regardless of the means at our disposal.

glossary

Acetic acid An acid used in diluted form as a stop bath for film and papers.

Agitation The process of keeping fresh solution in contact with film and paper surfaces.

Air bells Tiny bubbles of air clinging to film and paper surfaces during the development cycle. Vigorous agitation minimizes air bubbles.

Angle of view The area or view covered by the lens. Angle of view depends on the focal length of the lens.

Aperture The lens opening which regulates the amount of light reaching the film.

ASA Film speed rating used by the American Standards Association in the United States.

Barn doors An accessory on floodlights to control light intensity and direction.

Backlight Light or lighting behind the subject.

Bleaching A chemical process which diminishes the silver image of a print or negative.

Bounce light Light that is reflected from a ceiling, wall, or other surface.

Bracketing A method to insure correct exposure by taking extra exposures with values higher or lower than the normal exposure.

B setting A shutter setting indicating that the shutter will remain open as long as the shutter release is depressed.

Burning in A method of adding more exposure to selected areas of the print.

Cable release A flexible cable used to release the shutter.

Cadmium sulphide cells Cells used in some exposure meters for power.

Clearing bath A chemical used to neutralize acid chemicals like fixer and to shorten wash times with films and papers.

Color sensitivity Different films see colors differently. In black-and-white film, panchromatic film sees all colors, while orthochromatic film sees all colors but red.

Color temperature A scientific scale for expressing the color quality of a light source. The temperature is described in degrees Kelvin or °K.

Condenser A lens or lens system located between the light source and the lens on condenser enlargers. The condenser collects light and projects it through the negative and lens.

Contact sheet A printed to size record of a set of negatives.

Contrast The difference between two extremes of tone values, as in dark or light tone.

Density The amount of metallic silver on an emulsion. Dark negative areas would be known as high density.

Depth of field The zone of acceptable sharpness that is in front of and behind the subject that is in sharp focus.

Developer A chemical that converts a latent image on film or paper to a visible image.

Diaphragm A series of overlapping metal leaves that can be adjusted to specific apertures to control the amount of light entering through a lens. The aperture being used indicates the size of the diaphragm during exposure.

Diffuser Translucent material placed over a light source to soften or reduce contrast.

Diffusion enlarger A condenserless enlarging system that reduces print contrast.

Dodging A printing technique for holding back light in printing.

Easel Used with enlargers to hold printing paper flat.

Emulsion The photosensitized coating on photographic films and papers.

Equivalent exposure A shutter speed/aperture combination that can be adjusted to allow equivalent amounts of light to reach the film; i.e., f/8 at $1/125$ second allows equivalent passage of light as does f/5.6 at $1/250$ or f/4 at $1/500$.

Exposure The length of time for which a negative or paper is exposed to light. On film, the exposure is determined by the combination of shutter time and lens opening. On paper, it is the combination of lens opening and real time.

Exposure meter An instrument for measuring the light intensity of a subject. Reflected light meters measure the light reflected from a subject, while incident light meters measure the light falling on the subject.

F/stop, f/number The number used to indicate how large the lens opening is.

Film An emulsion layer of light-sensitive halides attached to a support base.

Film plane Location of the film in a camera and the point of focus for the lens.

Film speed see ASA and ISO.

Filter A transparent piece of glass or gelatin placed in front of the camera to alter the color of light during exposure. In printing, special filters are used with variable contrast paper to control print contrast.

Filter factor A multiplier of exposure value based on the amount of light a filter will absorb in order to avoid underexposure.

Fixer A chemical used in film and print development that dissolves unused silver halides.

Flash An artificial light source in the form of flash bulbs or electronically discharged lamps.

Flat A term that denotes lack of contrast in a negative or print.

Focal length The distance from the optical center of a lens to the film plane when the lens is focused at infinity.

Focal plane shutter A shutter located at the film plane.

Focusing Adjusting a lens to produce a sharp image.

Fog A masking of the image on the negative or print caused by extraneous light or by chemical action, or lack of it.

Grain Clumps of metallic silver on an exposed and developed negative. A mottled and uneven appearance on a print is due to clumped silver crystals.

Gray card A card that reflects 18 percent of the light falling on it. The card is equivalent to what an exposure meter measures when a reading is taken. Corresponds to the middle gray tone in panchromatic film.

Guide number An exposure-index value used in flash photography.

Hardener A chemical added to the fixer to harden a photographic emulsion.

Highlights Areas of reflected light. In a negative, highlights are dense. In a print, highlights are light or white in tone.

Hyperfocal distance The maximum depth of field possible when a lens is focused at infinity.

Hypo A popular term for a fixing bath.

Incident light The light falling on a subject.

Intensification A technique for increasing the density of negatives and prints.

ISO A world-wide film speed rating system used by the International Standards Organization.

Kelvin (°K) see Color temperature.

Latent image The undeveloped invisible image in film or printing papers.

Latitude The ability of black-and-white films to compensate for improper exposure and/or development.

Leaf shutter A shutter consisting of overlapping metal blades or leaves and located between elements of a lens.

Lens An optical element made of glass or plastic that brings closer together or sends wider apart the rays of light passing through it. In photography, a lens may be constructed of one or more elements.

Lighting ratio The relationship between key light and fill light intensities represented as differences in exposure between highlights and shadows.

Mirror lens A special lens that uses mirrors internally to increase the focal length without increasing the physical length of the lens barrel.

Negative An image on film emulsion produced by the product of exposure and development.

Newton's Rings Concentric bands of colored light seen when two transparent materials are slightly out of contact with each other, such as a negative and a glass-type negative carrier.

Orthochromatic film A black-and-white film sensitive to blue and green but not sensitive to red.

Panchromatic film A black-and-white film that is sensitive to all the colors of the visible spectrum.

Parallax The difference between what a lens and a viewfinder see. A problem common with optical viewing and twin lens reflex camera systems.

Photogram A shadow-pattern photograph made by placing opaque or translucent objects on printing paper and exposing the paper to light.

Perspective The relationship between a three-dimensional scene and its

representation in two dimensions in a photograph, i.e., distance is represented by the size of the object in a photograph.

Rangefinder An optical system which helps to bring a superimposed or split image together in order to focus a camera.

Reducer A solution capable of reducing the density of an overdense emulsion. The opposite of intensification.

Reflected light Light that bounces off or is reflected from an object.

Safelight A darkroom light whose filters keep white light from affecting photographic printing paper.

Selenium cell A cell used to power some exposure meters.

Shadows Any dark area of a print or light area of a negative.

Sharpness A film characteristic that refers to the capacity of the film to record distinctly fine lines between adjacent subject areas.

Shutter A mechanical device on a camera for controlling the duration of an exposure. See Focal plane and Leaf shutter.

Single lens reflex A camera type whose focusing, viewing, and exposing system is accomplished through the lens.

Spot meter A light meter that measures a small area of the subject.

Spotting The process of retouching to remove tiny specks from either a negative or a print.

Stop bath A dilute solution of acetic acid used to stop the developing action of certain films and papers.

Soup A jargon word used to indicate film development—as in "soup the film."

Synchronizer A device that is built into the camera shutter mechanism. It permits the simultaneous operation or synchronization of the shutter and flash.

Teleconverter An auxillary lens that is inserted between the camera and the interchangeable taking lens to increase focal length.

Telephoto lens A lens of longer than normal focal length.

Test strip A strip of paper used to determine the correct exposure for a print.

Toning A technique of using a chemical solution to change the overall tone of a black-and-white print.

Twin lens reflex A camera with two lenses. The top lens is used for viewing, while the bottom lens is used to make the exposure.

Variable contrast paper A printing paper with multiple emulsion layers sensitive to the colors of printing filters. Contrast is altered by using various filters.

View camera An optical system consisting of a lens, flexible bellows, ground glass viewing. Used for perspective correction and when a big negative is needed.

View finder An optical or frame finder used for viewing and composing the subject.

Wide angle lens A lens with less than normal focal length and a wide angle of view.

Wetting agent A chemical used in the film development process. It reduces surface tension on film and prevents water spots.

Zoom lens A lens with moving elements that permit various focal lengths to be incorporated in the design.

Zone focusing The near and far limits of depth of field for a particular f/stop at specified focus points. Useful in action photography.

bibliography

Aperture Monograph, 7:2(1959). This issue is devoted to the equivalent statement.

ASHER, HARRY. *Photographic Principles and Practices*, 2nd ed. New York: Amphoto, 1975. A highly detailed and scientifically oriented approach to photographic principles.

BLAKER, ALFRED A. *Photography, Art and Technique*. San Francisco, CA; W.H. Freeman and Company Publishers, 1980. Good illustrations and pictorial examples of various cameras and lenses.

Broncolor C70 and C171, pamphlet. Allschwill, Switzerland: Bron Elektronik, AG., 1983. Excellent illustrations of lighting techniques.

CLEMENTS, BEN, AND DAVID ROSENFELD. *Photographic Composition*. Englewood Cliffs, NJ: Prentice-Hall, 1974. Concentrates on the qualities and forces that work together to make strong images.

CRAVEN, GEORGE. *Object and Image*, 2nd ed. Englewood Cliffs, NJ: Prentice-Hall, 1982. Well-illustrated, fairly simple approach to exposure.

DAVIS, PHIL. *Photography*, 4th ed. Dubuque, IA: Wm. C. Brown, 1982. Contains good visual descriptions of standard finishing techniques. A well-illustrated treatment of common filter effects. Photographic section shows loading procedure for both steel and plastic reels. Good chapter on photographic trends.

DOTY, ROBERT. *Photo Secession*. Rochester, NY: George Eastman House, 1960. Probably the definitive work on the Photo Secession.

EATON, GEORGE T. *Photographic Chemistry*. New York: Morgan and Morgan, 1965. Difficult concepts explained at a novice level.

The Focal Encyclopedia of Photography. New York: McGraw-Hill, 1971. General technical and historical information in alphabetical order.

FRAIR, JOHN, AND BIRTHNEY ARDOIN. *Effective Photography.* Englewood Cliffs, NJ: Prentice-Hall, 1982. Chapters devoted to artificial lighting.

GASKIN, JAMES E., JR. "How to Use and Choose Studio Flash Equipment," pamphlet. Novatron of Dallas, Inc., 1983.

GASSAN, ARNOLD. *Handbook for Contemporary Photography,* 4th ed. Rochester, NY: Light Impressions, 1977. Deals with the problem of photographic meaning and special processes.

GRUEN, AL. *Contact Sheet.* New York: Amphoto, 1982. Selected photographers show their contact sheets, indicate their selections, and explain their choices.

HAYES, PAUL W., AND SCOTT M. WORTON. *Essentials of Photography.* Indianapolis, IN: Bobbs-Merrill, 1983. Compares properties of various film developers.

HEDGECOE, JOHN. *The Book of Photography.* New York: Knopf, 1976. A short, highly visual approach to basic printing. Good illustrative appendix of material on studio lighting, equipment, and flash. Outstanding examples of camera and shutter mechanisms.

Kodak Master Photoguide. Rochester, NY: Eastman Kodak.

LARMORE, LEWIS. *Introduction to Photographic Principles.* New York: Dover, 1965. A dated but concise description of the physical response of film and filters.

NEWHALL, BEAUMONT. *The History of Photography.* New York: Museum of Modern Art, 1964. Excellent source for early history.

Petersen's Darkroom Techniques. Los Angeles: Petersen Pub. Co., 1973. Good review of beyond basic printing techniques. May be hard to find.

ROSEN, MARVIN J. *Introduction to Photography,* 2nd ed. Boston, MA: Houghton Mifflin, 1982. Two well-illustrated chapters on studio and flash lighting.

SANDERS, NORMAN. *Photographic Tone Control.* Dobbs Ferry, NY: Morgan and Morgan, 1977. A handy work that is both thorough and readable. Gives the beginner a basis for experimentation.

SONTAG, SUSAN. *On Photography.* New York: Farrar, Straus and Giroux, 1977. A series of essays on the meaning of photography and what ordinary people do with the medium.

SWEDLUND, CHARLES. *Photography.* New York: Holt, Rinehart and Winston, 1981. Good chapter on lenses and effects, but pictures of cameras are dated. Excellent chapter on printing controls and evaluation.

UPTON, BARBARA, AND JOHN UPTON. *Photography.* Boston: Little, Brown, 1975. A thorough approach to the subject. Highly visual. Includes a good section on evaluation and troubleshooting.

Index